BASIC STUDIO *Lighting*

BASIC STUDIO

Lighting

THE PHOTOGRAPHER'S COMPLETE

GUIDE TO PROFESSIONAL TECHNIQUES

TONY L. CORBELL

AMPHOTO BOOKS
An imprint of Watson-Guptill Publications
New York

Photograph by Lyn Sims (c) 1999

Senior Editor: Victoria Craven
Project Editor: Alisa Palazzo
Designers: Leah Lococo and Jennifer Moore
Production Manager: Hector Campbell

First published in 2001 in New York by Amphoto Books, an imprint of
Watson-Guptill Publications, a division of BPI Communications, Inc.,
770 Broadway, New York, NY 10003
www.watsonguptill.com

Library of Congress Cataloging-in-Publication Data
Corbell, Tony L.
Basic Studio Lighting : the photographer's complete guide
to professional techniques / [Tony L. Corbell].
p. cm.
Includes index.
ISBN 0-8174-3550-6
1. Photography—Lighting. 2. Photography—Studios and dark rooms. I. Title.
TR573.C67 2001
778.7'2—dc21
00-054568

Manufactured in Malaysia

1 2 3 4 5 6 7 8 / 08 07 06 05 04 03 02 01

The Director of Photographic Education for Hasselblad USA, Tony Corbell has spent over 20 years in the photographic industry. He is the "dean" of Hasselblad University, founder of the International Wedding Institute, and prior to joining Hasselblad in 1993, was a faculty member at the prestigious Brooks Institute of Photography.

He has taught many photographic workshops in the United States and internationally, including Palm Beach Photographic Workshops, the Santa Fe Workshops, Tuscany Photographic Workshops in Italy, and workshops at numerous Professional Photographers of America-affiliated schools. In fact, he has taught over 80 seminars, workshops, and lectures in 40 states. In the past six years, he has spoken at every major photographic convention in the US, and has served as chairman of PPA's Educational Committee and also as venue photo manager for the Atlanta Olympic Games. He was associated with Dean Collins and the Finelight organization for several years, where he produced and wrote their popular, eponymous series of books and videos, and won numerous video-directing awards.

His photographic clients have included Presidents George Bush and Gerald Ford, The Smithsonian Institute, and Eastman Kodak Company. In September 2000, he worked with Eastman Kodak to shoot a historic picture of the United Nations Millennium Summit that included the leaders of 129 countries (see page 52). He is also the recipient of the March 2001 Lifetime Achievement Award from Wedding & Portrait Photographers International. He lives in San Diego, where he often listens to Beatles music and watches John Wayne movies.

Acknowledgments

EDIE AND LESLIE HAVE HAD MORE PATIENCE with me on this project than anyone should ever have to endure. I thank them and love them. I wish to thank my brother-in-law Raymond "Sonny" Taylor for my first job in photography. He and my sister Teri took a chance on me in the late '70s and I hope I've not disappointed them.

Everyone at Hasselblad USA has been tremendously supportive, especially company president Allen Zimmerman. Richard Schleuning and Bob Nunn have also been there, as well as the ever-present, unflappable Jim Morton. Thank you all.

I want to thank Terry Deglau at Eastman Kodak Company for his friendship, support, and for all the amazing people we have photographed together from world leaders to models. Skip Cohen from photoalley.com for the past 12 years has been my friend, my boss, and often my inspiration. Thank you, my friend. Claude Bron from Bron Elektronik in Switzerland has also been a strong supporter of mine over the years, and I want to thank him.

No one has been more patient with me on this project than my friends at Amphoto/Watson-Guptill, Victoria Craven and Alisa Palazzo. They have waited and waited and waited and I thank them both. I also wish to thank the staff and faculty at Brooks Institute in Santa Barbara, CA; Photo District News technical editor Joseph Meehan for helping me decide to begin this project; and Woody Wooden at CCSN in Las Vegas for the never-ending encouragement. Thanks to all of my former students who just would not stop asking questions and for all of the Texas photographers who have helped shape my career. Thanks also to the IWI students for the past three years, for their support and encouragement always.

Last but not least is photographer/educator/lecturer Dean Collins. Dean changed the way we as an industry learn about our craft. He identified what photographic education could be and set about doing something about it. He changed our world, and we should all thank him. I'll do it for the rest of you.

TECHNICAL NOTES

Every picture in this book was taken with a Hasselblad camera. I would not have it any other way. Having started my journey through this career in a studio, and not as an amateur photographer, I took for granted that my very first camera was a Hasselblad. It was my starter camera, weekend camera, wedding camera, commercial camera, and has carried me through until today. With the exception of two really lousy years in the middle when I tried another brand, I have always worked with Hasselblad cameras and have never been disappointed. The quality and workmanship are unparalleled, and without a doubt, Hasselblad will help make you a better photographer. Plus, it fits perfectly in your hands. Also, there is not a better friend to photographers or a more supportive company in the industry.

Every picture in this book was lit with a VISATEC light made by Bron Elektronik. These monolights are, without question, the finest in the world. They have an amazing ability to produce consistently clean light that has the truest color temperature I have ever seen, from lowest to highest power. In addition, the airline baggage handlers cannot beat them up, although they often accept the challenge to try. Kodak films have been in my camera case since I started. Having no formal schooling in photography, most of what I learned came from seminars, workshops, and lectures, and over the years, Kodak always supported those efforts. They have my undying gratitude and loyalty for whatever knowledge I might have.

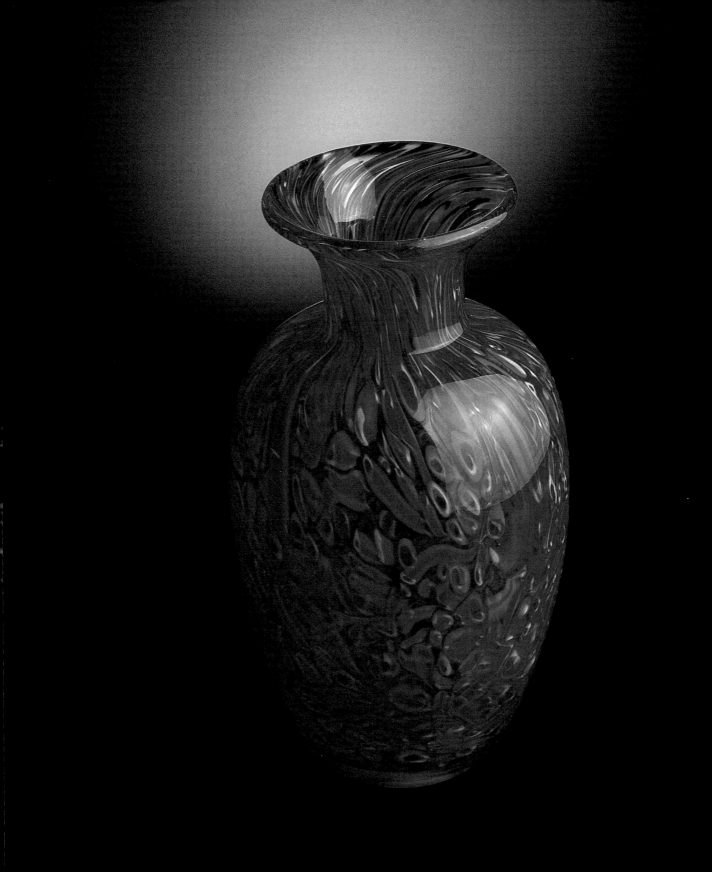

This book is dedicated to all the great and not-so-great photographers, filmmakers, and cinematographers from whom I have learned. They all shaped my vision and ability to teach what I see.

—TLC, San Diego, 2001

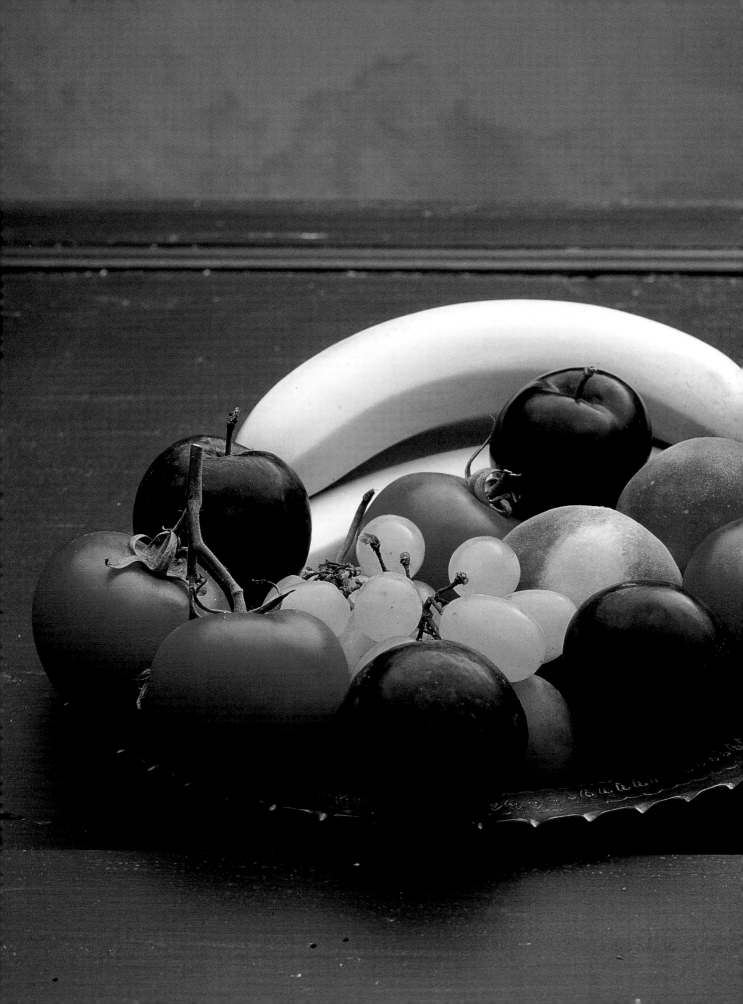

[CONTENTS]

Introduction 10

CHAPTER ONE
Basic Strategies of Studio Photography

14

CHAPTER TWO
Choices in Lighting Equipment

42

CHAPTER THREE
Principles of Light Control

68

CHAPTER FOUR
Measuring the Quantity of Light

84

CHAPTER FIVE
Keeping It Simple: One-Light Setups

106

CHAPTER SIX
Lighting for Depth

122

Resources 142
Index 144

Introduction

THE PHOTOGRAPHY STUDIO—what a scary place for those who haven't worked there before, but what a fantastic place for those who have mastered the craft. And, there's a mountain of information in between these two ends of the spectrum.

One of the many things that undoubtedly attracts so many photographers to working in a studio is the idea of controlling the look of a particular subject. Whether photographing a person or a product, photographers new and old want control: control over light, mood, *the look*—all the elements that come together to make a successful photograph. It's in the studio that photographers can use a wide range of light modifiers, such as umbrellas, soft boxes, grid spots, scrims, and diffuser panels, to shape and direct the raw light from an electronic flash or continuous light source to obtain exactly the desired results. Some of these light modifiers have unique designs and carry manufacturers' claims of all sorts of seemingly automatic results.

As every studio photographer quickly learns, there's more to successful studio lighting than the effect of any one particular piece of equipment. The look of any lighting setup is the combined result of a number of factors, such as the size of the main light relative to the size of the subject; the size of the light relative to its distance to the subject; and the exact placement of the light and the use of other secondary lighting, such as fill lights, accent lights, and background lighting. In short, the key to successful studio lighting comes less from the reliance on specific equipment and more from the ways a knowledgeable photographer uses that equipment. Lighting control is at the same time the most challenging and the most personally rewarding aspect of working in a studio. If you've mastered lighting, you are in total control of your photography.

The control over lighting that a studio photographer has does not mature or flourish until there is a clear understanding of both the physical characteristics of light and how a subject responds to that light. Even the slightest change in variables, such as the exact placement of a main light or the ratio between the amount of main light versus the amount of fill light, can significantly alter the final results. These changes range from subtle to extreme and give photographers plenty of opportunity to develop their own style.

Overlooking the need to build a foundation of lighting knowledge is probably the single most important reason why so many photographers fail to experience the true creativity and enjoyment of photography. Consequently, they try to copy what they see, understanding only *how* it was done, not *why*. If there's a key to successful studio lighting, it is learning the basics and using this knowledge to illustrate one's own ideas.

Most photographers work in natural light before they move into the studio and feel confident that they're well prepared to deal with artificially generated light sources. After all, photographers have been told for years that light is light, no matter where you find it. Natural and studio-generated light have the same general characteristics and behave in the same way. However, there are significant differences that are worth pointing out. In the field, photographers are used to looking for and finding just the right light. In the studio, they have to create this light entirely with equipment. In addition, the studio provides for the use of different sources, with the option to have light strike the subject from more than one direction. This presents many more choices than outdoor photography where there is basically one directional source of illumination.

The sun is not only a single light source but is also hardly portable. Consequently, photographers adjust the subject

and/or camera position until they get a desirable angle or perspective on their subject and background, and they don't worry about anything but the perspective of the picture. In the studio, the reverse is true: The subject is usually positioned first, then the lights are set up. Deciding what type of main light to use and where to place it relative to the subject are the two most critical decisions a studio photographer must make. After that, it's the subtlety that makes the difference in lighting and the impact on the final image.

Working with studio lighting is more complex than working in natural light, but it's this complexity that presents an unlimited number of opportunities for unique and creative results. Sadly, many photographers tend to settle on a handful of what become routine lighting setups, and then on what other photographers are doing, for new ideas. There's nothing wrong with adopting the lighting arrangements of others. In fact, new photographers are encouraged to study the work of other photographers. There's also nothing inherently wrong with sticking with just a handful of setups that work, but there is the danger of limiting your creative potential. To succeed and grow in

professional photography you must develop your own distinctive, evolving style.

In the early 1980s, noted photographer/lecturer Dean Collins visited me in Texas and suggested as we left my studio one evening that I put away all of my lights at the end of the day. He said, "After all, you wouldn't want tomorrow's first session to look like today's last session." In the past 17 years, I've never forgotten this casually mentioned advice.

You must discipline yourself to learn as much as you can about light and the use of lighting equipment. Do it right, and the rewards are enormous. To that end, let's begin with developing a strong foundation of basic information about exactly what controls you have at your disposal. We're going to turn you into an informed photographer, knowledgeable in all aspects of lighting. You'll experience substantial growth and a renewed excitement and creativity you may not have thought possible. You'll also develop a sense of confidence allowing you to take on more and more complex work. I hope you enjoy this book and that you find it helpful in becoming the type of photographer you wish to become.

BASIC STRATEGIES of

Studio photographers generally approach their subjects with the idea that the final image will be the result of a careful and logical building process. They will select light sources, light modifiers, and other tools, such as reflectors and gobos, and combine them until they achieve the desired effect. This building process is simply the result of their way of thinking about the subject and the equipment,

Studio Photography

directed by four factors: the purpose of the photograph; the physical characteristics of the subject; the personal style and preferences of the photographer; and the demand, mind-set, or mood of the client. Before reaching for any lights, studio photographers usually have a good idea of what they are trying to achieve and how the subject will react to various light sources, as well as a strategy to carry it all out. Of course, in the case of commercial advertising photography, the client or art director's opinion has a great deal to do with the overall "look" or mood the studio photographer creates.

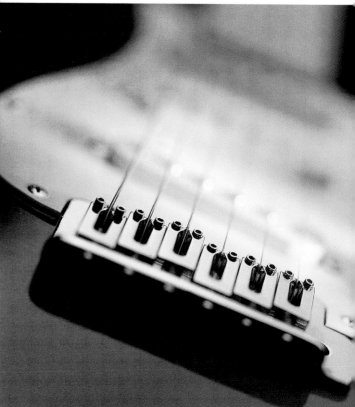

A noncreative record or documentation of a product is often necessary for publicity and sales promotions.

By contrast, creative interpretation of the same subject offers a great opportunity for self-expression.

Thinking like a Studio Photographer

WHILE STUDIO PHOTOGRAPHERS CAN CREATE and control all of the light used to take a picture, they still have the same problem all photographers have: *how to deal with the limitations of a two-dimensional medium to record three-dimensional reality*. The final image is only capable of recording the dimensions of height and width, while the real world has the additional quality of depth. The ability to control dimensionality, such an important skill in studio photography, will be covered later on in chapter 3. However, before we can discuss the issue of control, we must first establish the basic thought process that most studio photographers follow when approaching their work.

The basic intention of most studio photographers is to arrange the lighting to record certain characteristics about the subject, such as its overall shape and color as well as the nature of its surface in terms of texture and contours. The general strategy shaping the presentation of these characteristics tends to favor one of two approaches: either to document the subject or to interpret it.

For example, the need to give as accurate a representation as possible is the approach in most medical photography as well as in the documentation of works of art. Much of what is called product photography, usually found in sales catalogs, is also concerned with an accurate representation of the color,

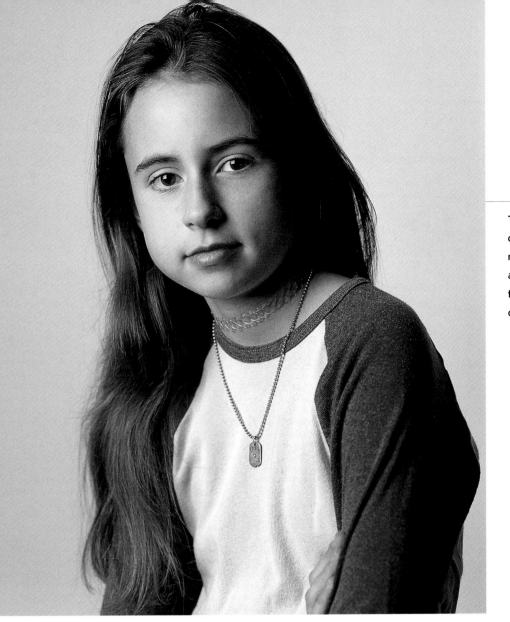

This is a good example of a documentary or record-keeping image, as may be required for passports, visas, or driver's licenses.

texture, shape, and so on of the products being depicted. This also applies to those styles of people photography for which the purpose is to record a person's image accurately, as in group or team pictures and typical school and studio portraiture.

On the other hand, many types of still-life settings created by commercial and fine-art studio photographers, higher-end product photographers, and some portrait photographers tend to emphasize certain characteristics of the subject while playing down others. The idea here is to interpret various charac-

teristics of the subject in some way. This begins with such basic decisions as selecting which side of the face will dominate a portrait or using the subtle effect of shadows to convey the contours of a flower in a still life. There is also the introduction of emotion and the mood of the picture. A mood can be established easily with choices in color temperature and the key of the background. In other words, is the feeling warm and airy or cool and dark? The studio photographer can easily manipulate these moods.

Creative interpreta-
tion when photograph-
ing a person is as
important to develop-
ing style as it is in
product photography.
Here, I created the
dynamic angle by sim-
ply tipping the camera,
giving just a bit more
impact to the picture
and filling up the
square composition.

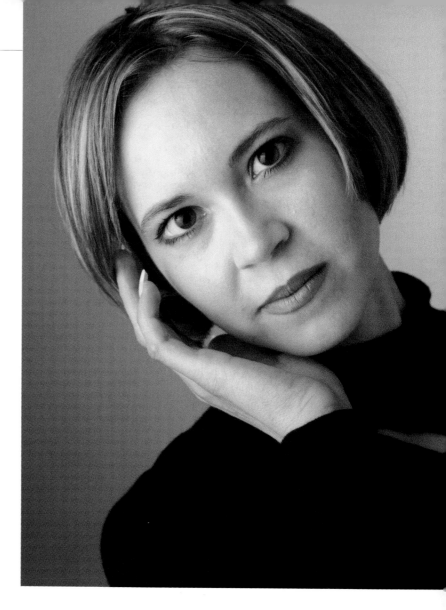

Because the *interpretive approach* provides for so many more variations and opportunities for creating different looks, it is here photographers tend to develop individual lighting styles to give their work a particular look. The *documentary approach,* while less dramatic and singular in appearance, requires an excellent understanding of how different lighting will accurately repro-duce the main physical characteristics of the sub-

ject. Photographing glassware and highly reflec-tive jewelry are two challenging examples.

Most studio photography is a combination of documentary and interpretative approaches. Regardless of approach, the common goal is to accurately represent the main characteristics of the subject, while also interpreting certain quali-ties and then adding, perhaps, a specific mood to the lighting to make a personal creative statement.

Utilizing the latest
in software, processing
manipulation, and
other creative
tools, offers unlimited
opportunities for
experimentation.

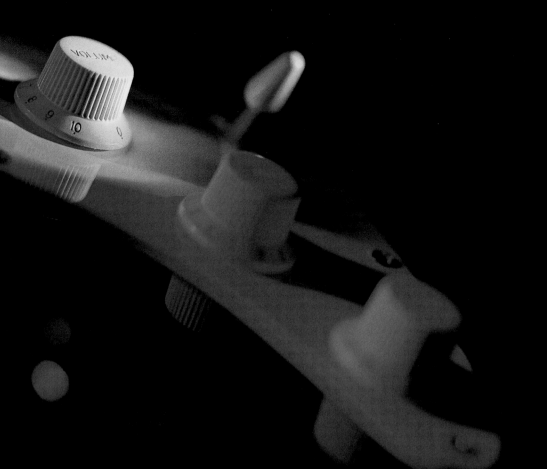

Personal interpretation of a product or subject always adds to the quality of the image. This close up of an electric guitar explores the idea of directing the viewer's attention in a creative, more interpretive way.

Even in a more documentary approach, highlights need careful controlling. This watch offers a good example of the reflective properties of chrome.

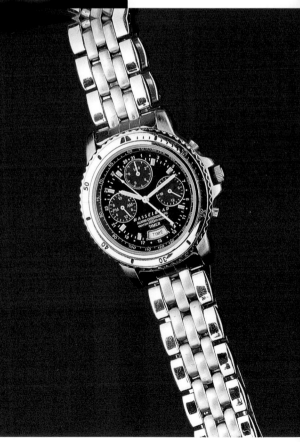

There is an ever-present challenge when photographing highly polished products or subjects. This image shows a blending of both interpretive and documentary approaches. However, regardless of which approach is used, understanding highlight controls is of key importance as highlight control can make an image succeed or fail.

Frontlighting illustrates the nondirectional, "flat" look often associated with an image without depth.

Considering the Subject

UNDERSTANDABLY, STUDIO PHOTOGRAPHERS tend to think of their subjects in concrete terms, asking questions such as: How should the subject's overall shape be recorded against a particular setting? Is it important to bring out surface contours? Is surface texture important for this picture? Is this an important characteristic that should be emphasized or played down? Is the subject's surface smooth enough to produce distracting bright reflections? What about the colors of the subject and how will they appear against certain background colors or shapes?

These are just some of the considerations that will run through the mind of an experienced studio photographer, and it is good practice to begin, from the start, to scrutinize your subject, working out some idea of how you want to portray not only the subject as a whole, but also its individual physical characteristics.

There is a very practical reason for such a strategy. Various light modifiers and their placement relative to the subject can significantly alter the subject's physical appearance. For example, just switching the main light from a front position to a side position, relative to the subject, will significantly change the way any surface texture is recorded and, if your subject is a person, can elongate or foreshorten the width of the face.

PHYSICAL CHARACTERISTICS OF THE SUBJECT

Whatever the purpose of the picture, the studio photographer must always build an image of the subject by working with its basic physical characteristics. Generally, this means considering four qualities:

1 The overall shape or outline of the subject.

2 The appearance of any surface contours and shapes that help form an impression of the subject's three-dimensional qualities.

3 The presence of surface texture.

4 The color or, if you're working in black and white, the tonal range of grays of the subject.

As light direction changes, texture and depth become more apparent and much more dramatic. Dimension can only be seen in a photograph with highlights and shadows. Front-, or flat-, lit photographs, while recording a subject, fall short in creating depth.

Backgrounds don't necessarily need to be bright and centered behind every subject. Often, a subtle, less obvious background light is all that's needed to introduce dimension to an image.

The Setting: Backgrounds and Foregrounds

ONCE THE BASIC DECISIONS have been made about how to portray the subject, the next point to consider is the question of what role the setting will play in the picture content. While every photograph may not have a prominent foreground, every image has a background, even if it is just black or white or a single color. Typically, these ground areas give a sense of depth to the picture or frame the subject to reinforce a certain composition. Many photographers favor the rule of thumb that foreground and background settings are just that: settings, against which the most important element—the main subject—is placed. Therefore, when lighting these areas, the best guideline to follow is to support, and not draw attention away from, the subject.

There are plenty of photographers who take exception to this and see the setting as an extension of what they are trying to do with the subject. Consequently, they place an emphasis on certain aspects of the ground areas almost as a trademark of a particular lighting style. As long as you are controlling the effect and pleased with the results, this type of stylized shooting is what most photographers are looking for: a way to express themselves.

Whatever strategy you choose to follow, it's helpful to remember that the purpose of the photograph, in terms of the main subject, should be clear in your mind before going on to consider what to do with the background and foreground. It is also important to remember that this is a key area where your creativity will begin to shine.

Controlling every element in this studio photograph enabled me to get predictable results in the background, the reflections in the silver studs on the clothing, and even the warmth of the skin tone. A complete understanding of photographic technique is essential in order for today's photographer to succeed.

Deciding on a Plan

THE MAJOR THEME of this chapter so far has been the importance of thinking like a studio photographer—to approach your subject with at least a general idea of what you want it to look like relative to a particular setting and to decide on a logical procedure to follow in pursuit of that idea. You've got to have a plan! It's surprising how many photographers start out, without any idea of what they're trying to achieve, by simply raising any background that is on hand, then moving lights around until they stumble onto something they like. As long as someone likes it or a client buys it, what's the purpose of trying to improve, right?

Not really. Plan to have a general concept of what you're trying to accomplish right from the start. This will make the selection and placement of light sources and backgrounds a far more logical process. This is also much more efficient than relying on trial and error. Yet, even in such organized strategies, there should still be plenty of opportunities to experiment and to explore creative variations.

It has been said that when working outdoors, you tend to record what is there; yet, when working in the studio, you tend to create what is not there. You set the tone for the viewer's assessment of the image.

How do beginning studio photographers build up an appreciation of different lighting effects or develop a sense of what they want to achieve? One of the best ways is to look at the work of other photographers in magazines and books. If you can, begin a clip file of those examples you particularly like and make notes as to why they appeal to you. Try to analyze the type of lighting used. Put yourself in the place of each photographer and try to figure out not only how a particular image was lit but why.

One recommendation that is particularly helpful is to begin a portfolio of your own work when you first start out. Keep a set of notes about what you were trying to create as well as what you did in each picture. It might be helpful to take a few shots of each lighting setup or a diagram.

It's surprising how much we forget as soon as the shoot is over, the equipment put away, and we're looking at just the results. Many photographers keep their Polaroid test shots as "proofs" of both the subject and the lighting setup, using the back to jot down notes about exposure, lighting, and so on. Well-known New York

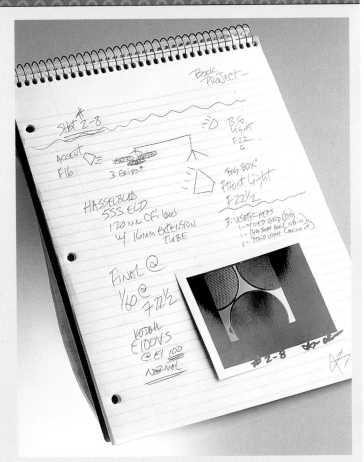

A "comp" book or notebook in which you keep detailed notes, Polaroids, and drawings from a shoot will help in recreating techniques in the future without the burden of retesting the same technique numerous times.

photographer Howard Schatz meticulously documents every aspect of every shoot and keeps a highly accurate notebook as a reference guide for future ideas.

Attend every seminar and hands-on workshop for which you can find the time and money. This will both increase your knowledge of studio work and keep you from falling into the rut of the same routine all the time.

Types of Light

ONCE YOU MAKE A DECISION about how to render the subject, you can begin setting up the specific lighting design that will deliver the desired results. The strategy here is to follow a building process using each light in the following logical sequence to perform a certain function:

1. Main or key light to provide the overall illumination, much like sunlight outdoors.

2. Fill light to control the density of the shadows produced primarily by the main light.

3. Accent lights to bring out or accent details of the subject by outlining and high-lighting; also used for separation of the sub-ject from the background to add dimension. Depending on the subject, there may be multiple accent lights.

4. Background lighting, which can be either separate lighting to illuminate the back-ground area, spill light (additional light) from the main light, or the isolation of the background so that it appears completely black.

5. Foreground lighting to provide light to the foreground on occasions that it might need separate illumination.

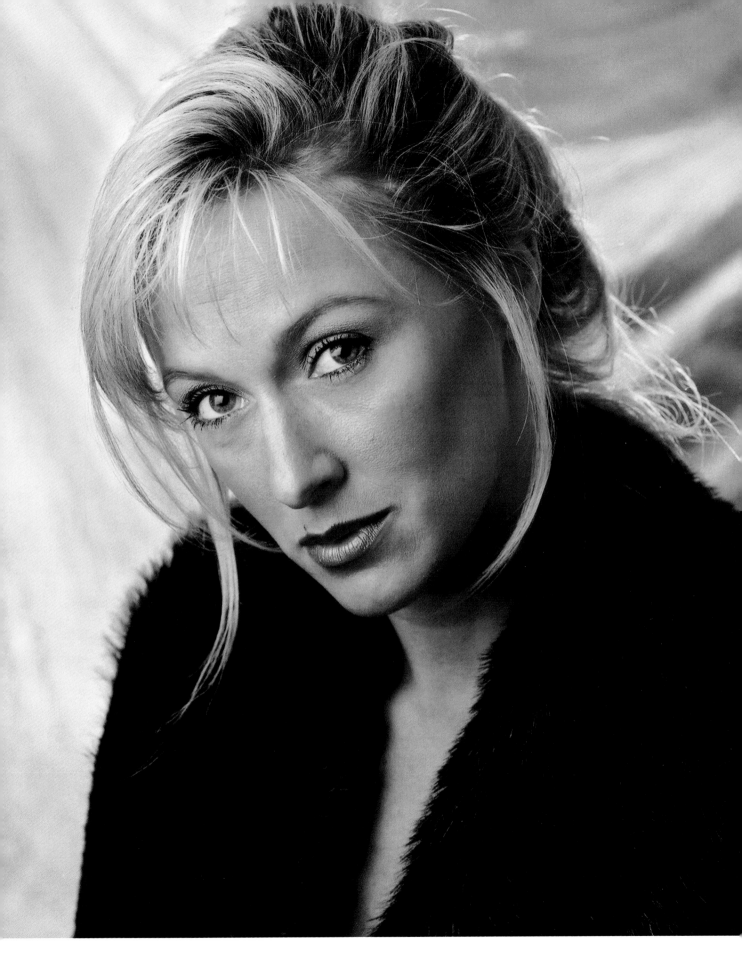

As the building process
begins, the main light
establishes the basic
direction and type
of overall lighting
setup to be used.

The addition of
the background and
its lighting separates
the subject and
gives the appearance
of further depth
and dimension.

When a reflector is
added as a fill light,
the contrast of the pic-
ture becomes apparent.
A reflector offers
an easy solution for
varying the contrast
range quickly and
predictably. What
you see (through the
viewfinder) is what
you get (in the final
image). This is also
known as "WYSIWYG"
(pronounced *wiziwag*).

A separation accent
light further enhances
depth in a photograph.
It can also be used
to affect and control
brightness, color,
subject size, and
placement.

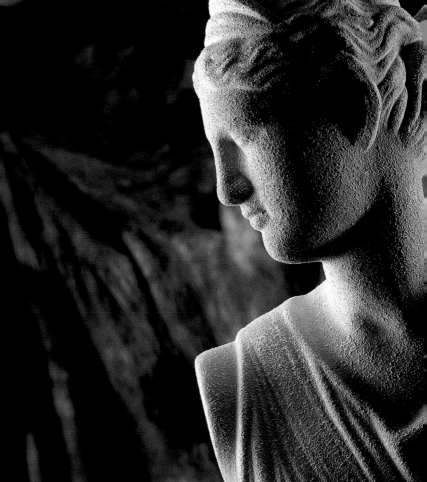

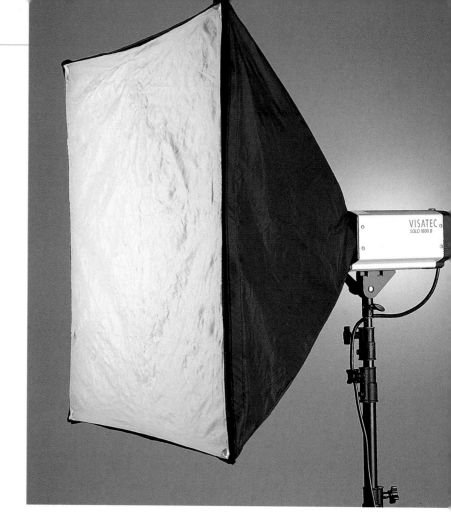

Light from a soft box is very contained, thereby offering the photographer the ability to keep light off of backgrounds and other areas in a scene. Soft boxes and light banks are extremely popular with portrait and commercial photographers due to their controllability.

MAIN OR KEY LIGHT

The foundation of every lighting arrangement or setup is the main or key light, since this light has the largest role to play. It is the first light to be positioned and is responsible for generally illuminating the subject and setting up the overall desired look. Thus, the main light usually establishes the following:

1. The general size and/or shape of the subject.

2. The color or the tonality (for monochrome images) of the subject.

3. The presence or absence of shadows, which plays a major role in creating the impression of dimension.

4. The shape and size of bright reflections, such as the catch light in the eyes or other bright reflections coming off other smooth or reflective surfaces.

5. The overall impression of contrast (as in a hard, medium, or soft look to the subject).

6. The starting point for determining correct exposure.

Typical main light sources are soft boxes, large parabolic reflector heads, and umbrellas or diffusion panels. Actually, you an use any form of light, from a spotlight to a huge bank of soft boxes or even a bare bulb source, as a key light. It's largely a matter of fashion and style that soft boxes, umbrellas, and diffusion panels have emerged as the most common form of main light sources. Each has its importance, depending on the photographic need. For example, an umbrella is the perfect choice when photographing a group of several people, due to its large spread or area of coverage. However, a soft box is ideally suited for photographing an individual person, when you need light control and must minimize spill light.

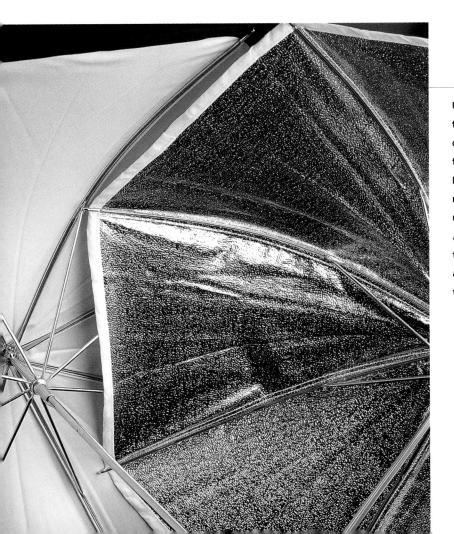

Umbrellas are often the light shaper of choice for many photographers who have large areas to illuminate. Umbrellas are usually silver or white. Also popular is a translucent fabric that allows light to fire through the umbrella.

Main light alone on
a product or still life
performs the exact
same function as
it does in a portrait
image—to provide
primary illumination
of the subject.

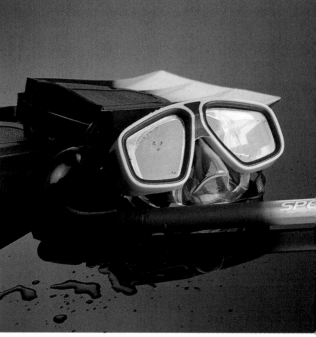

The background,
in this case reflected
into a highly polished
black Plexiglas sheet,
enhances the product
color and depth.

The two most critical factors that affect the overall appearance of a subject are the size of the main light (as compared to that of the subject) and its position (relative to the subject). This will initially establish contrast, which you can then refine by the use of fill and accent lighting. Typically, terms such as hard, medium, or soft light are used to describe the effects of not only the size and placement of the main light but also the refinements produced by the fill and accent lighting.

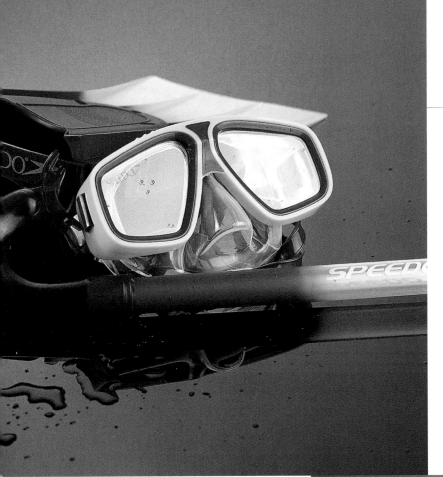

Additional fill and accent light from camera left helps identify the product logo more easily and offers more information about the surface of the product.

A small sheet of black paper placed on the front "skin" of a soft box helps reduce highlights in the glass portion of the mask—increasing transparency of, and allowing us to "see through," the glass.

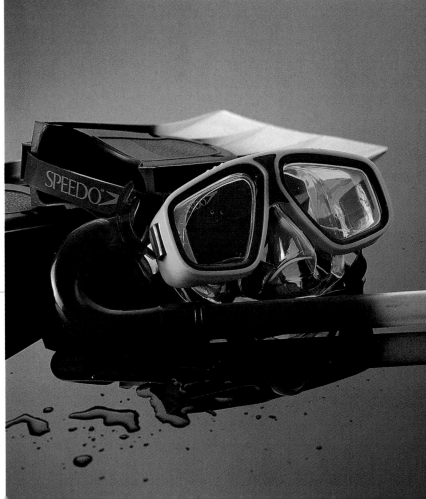

FILL LIGHT

Once you establish the general effect of the main light, the next consideration is what to do with the shadows cast by the key light. A good solution: the use of "fill." A fill light opens up the shadows often allowing more details to be recorded on film than without its use. It also tends to lower the contrast between the brightest areas illuminated by the key light and the dark areas caused by its shadows.

A fill source can be either a second light diminished in intensity from the main light, or some of the spill from a main light redirected into the shadows by the use of a reflector. By definition, a fill light is nondirectional.

The amount of light that you use for fill is relative to the intensity of the main light. Most frequently, photographers will set the fill source at some level below the intensity of the main light so that there are still shadows present to help define the depth of the subject. Occasionally, the fill is used to eliminate the shadows completely, acting like a second main light. (In chapter 4, we'll see how to control contrast and how the amount of fill versus main light is measured and expressed as a lighting ratio measured in f-stops.)

A fill light is not always necessary. In fact, many photographers don't use one. It's another tool, and a knowledgeable photographer will use all of the tools available as needed.

A high-contrast portrait (like the one opposite with strong contrast between dark shadows and light areas) creates drama, and may add a hint of mystery to an image while also minimizing the amount of equipment necessary.

In a portrait, you can easily adjust and control the range of contrast on the subject's face by utilizing a reflector as a fill light. By simply moving the reflector closer to the subject, you can quickly affect the range of contrast and make a decision about it. When working with one to four people, consider using a reflector rather than an additional light source.

ACCENT LIGHT

One or more accent lights are used on the subject—or anywhere else on the set—to literally accent an area, such as to bring out the texture of the hair in a portrait or to produce a bright thin outline on a vase in a still life. You can use a wide range of light modifiers for accent lighting, depending on how large an area is involved and what type of accenting is desired. You might add a splash of bright illumination in a limited area, as is the case with a hair light or a bright accent light off the side of the face in a dramatic portrait. Another form of accent lighting is the use of a thin line of rim light to accent the outline of a subject.

Accent lights are just that: accents. They should not take away from the overall feel of the primary subject and should only enhance depth and dimension by accenting certain areas of the photograph. My good friend Don Blair calls his accent lighting *garlic* lighting. According to him, it's just like garlic: When you get it just right, it's perfect, but too much is too much.

The accent light—often referred to as *kicker*, *separation*, and *skid* light—creates added depth and dimension, further enhancing the true shape of objects of all kinds.

In a portrait, the accent light can help identify true shape as well as separate the face from a dark area such as a background. Acceptable brightness of accent lights is very subjective and you can easily control it by adjusting power output of the source of illumination.

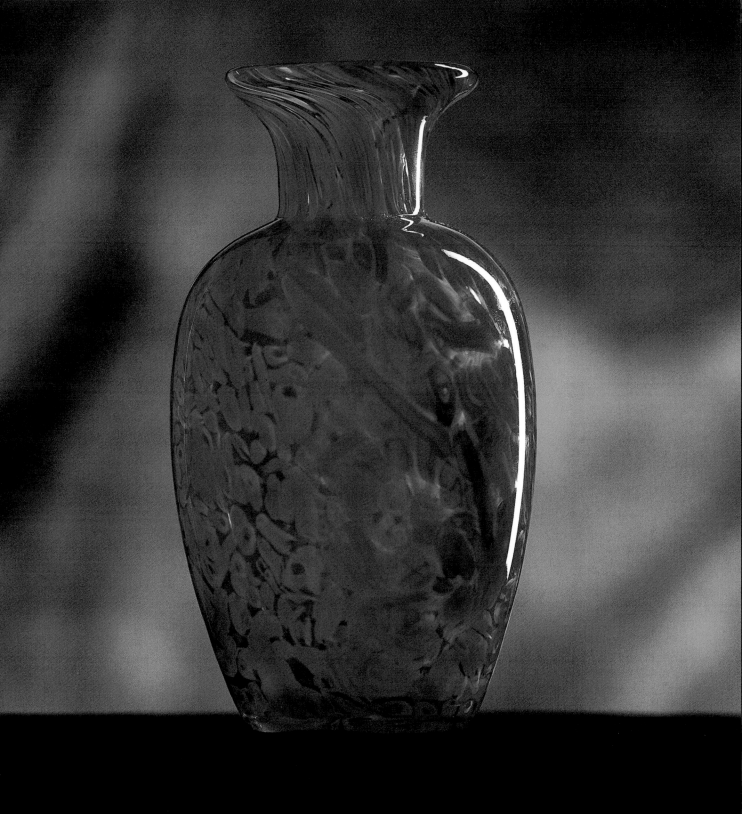

By setting up a back-
ground light directly
behind the subject,
you cannot fully realize
depth in an image, as
highlights and shadows
are minimized due
to the lack of direction-
al lighting.

BACKGROUND AND FOREGROUND LIGHTING

Lighting a subject's setting or environment usually involves dealing with the
background, since foregrounds are often illuminated by the main light.
Materials used, when you're creative, can be quite varied for backgrounds.
They can range from seamless white or colored paper to multicolored fabrics
that you can drape to form different contours and textures. You can also
change their colors by the use of theatrical gelatin filters. Thus, how a back-
ground is to be illuminated will depend very much on what it's made of, as
well as the intent relative to the subject.

In general, the same principles that apply to lighting a subject also apply
to the background. For example, placing a light to the side of either the sub-
ject or the background will cause longer shadows to appear. This is particu-
larly effective in bringing out the contour folds and surface texture of fabric.

IS ONE LIGHT REALLY ENOUGH?

I'm often asked the following: I've heard that some master photographers keep everything simple and often use just one light and never bother with much else—is this true? There's no question that very impressive portraits and still-life photographs can be achieved with just one main light. After all, many of the masters worked primarily outside with the sun as their only light or indoors with only window light. That practice continues today with such outstanding photographers as Lord Snowdon, who is renowned for beautiful and dramatic natural light portraits taken in his studio, which resembles a small greenhouse.

But the larger question is whether or not you want to work only with one light source in all of your pictures. Throughout this book I present the full range of lighting controls using multiple lights in order to demonstrate just how much variety can be achieved. However, also consider what can be done with just one light, in chapter 5. In the end, it's up to you to choose how many lights are needed to produce the effects, impact, and impressions you want.

By simply moving the background light off to one side, "skimming" the light across the background, a perception of depth is much more evident and adds interest.

CHOICES in

Lighting equipment manufacturers have worked hard to provide photographers with a wide range of devices to shape, control, and measure light in the studio. Therefore, the new studio photographer is confronted with what seems like a confusing number of choices. But, if you know what you're trying to do, your needs in lighting equipment will

Lighting Equipment

be more obvious. Putting together all the components for a studio or a location lighting kit comes down to identifying needs and individual budgets, as well as having a knowledge of the various types of tools. In order to provide information for a wide range of needs and budgets, this chapter is organized into three main sections: electronic flash, light modifiers, and support and grip equipment.

A flash tube consists of a glass tube filled with xenon gas and a trip wire that awaits the closing of a circuit from the capacitor in a flash system to trigger the flash. Also, the modeling lamp can easily be seen and does not affect the exposure in a photograph, merely acting as a visual aid.

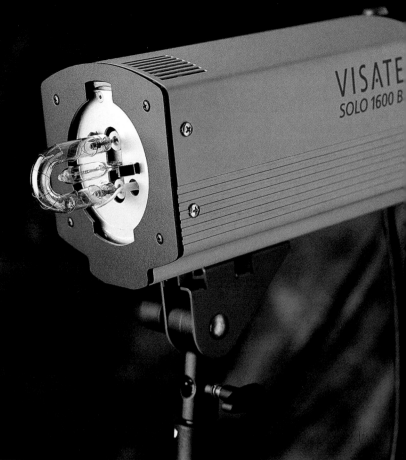

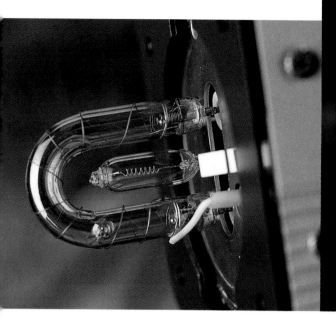

Electronic Flash

ELECTRONIC FLASH has emerged as the most popular raw light source for the studio because it supplies enormous amounts of light without significant heat buildup or a large amount of power consumption, while delivering bursts of light short enough to freeze movement. The critical questions to ask before deciding on what brand or style to buy are: What are my typical *f*-stop requirements as dictated by depth of field for my typical camera format, most common film speeds, and so on? How much time do I typically take between exposures, and how critical is it to freeze any action?

The answers to these questions will give you an indication of how much power you'll need, what recycling time is required, and what sort of flash duration is necessary to freeze action if the picture calls for stopping motion.

In general, 35mm fashion shooters need moderate power, fast recycling, and short flash duration, while large-format and still-life photographers need much more in terms of power output, with recycling time and flash duration being far less critical. In between are 35mm and medium-format photographers who have needs for all categories. The number of lights you require will depend on your style and specific lighting setups. For example, a portrait photographer may choose to work with two to four or even five lights, while a location photographer may need up to six or seven lights.

A portable flash has the same basic function as the studio strobe. However, features such as portability, automatic and through-the-lens (TTL) settings and power output are all differences.

While manufacturers publish basic specifications, such as recycling time and flash duration, the big question of how much power in *f*-stops the unit actually delivers to a subject is more difficult to answer. Certainly, all manufacturers publish specifications about power levels, most commonly in watt seconds or joules. But you need to know what the design of a particular flash head in a particular light modifier will deliver to a subject in *f*-stops at a certain distance, with a particular film speed or ISO. The best approach would be to test the actual combination you want and many camera stores will help you do that. An excellent approach is to rent the entire setup you're considering and test it yourself.

Several manufacturers have data sheets indicating the actual *f*-stop power for a certain distance (usually 10 feet) that their units will deliver in some representative light modifiers. They may also supply review articles from photography magazines that will provide some of this information. Be careful when reading manufacturer's information for output and be sure you are comparing the same type of equipment. For example, one manufacturer's standard reflector head may read very hot or bright in the middle of the beam of light, while the edges show a dramatic light falloff. This may be a bit misleading to the photographer who doesn't thoroughly test the output, its pattern, and the "shape" of the light delivered from any given

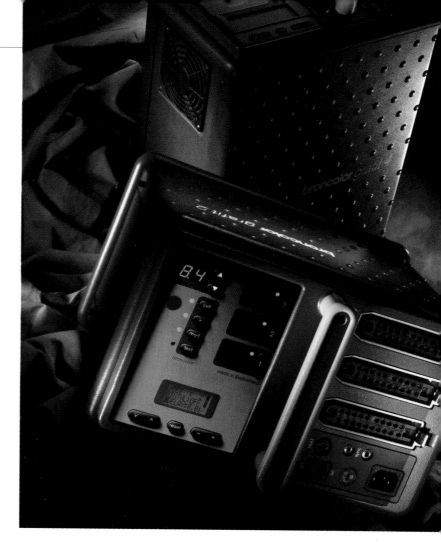

State-of-the-art power packs, such as this high-end model from Bron Elektronik in Switzerland, offer additional features including fast recycle time, digital display, 1/10 stop output control, and color temperature variations.

head. Another brand may read less bright in the middle but more even across a given area, giving a more acceptable overall lighting pattern. It's also important to factor in the opinions of, and recommendations from, other photographers. Photographers who are unhappy about any piece of equipment, from cameras and lenses to lights, will generally tell you the facts about their experiences.

Also to be considered are a number of operational factors that result from the differences between the two basic forms of studio strobe: the studio power pack and the self-contained studio flash. A studio power pack consists of a separate power supply box, or generator, that powers a number of flash heads connected to it by cables. The self-contained studio flash, on the other hand, combines the power supply and flash head into one package just as a small portable camera flash does but with a lot more power. Throughout this book, I'll use the terms "strobe" and "flash" to refer to both studio-pack and self-contained models.

There are advantages and disadvantages to both these forms of studio strobe. As a general rule, studio power packs are the most powerful and usually have the fastest recycling times. You can set the output of all the flash heads from the pack in various ratios (see pages 102–105), and the heads in most moderate to expensive brands are almost always fan-cooled, which is very helpful at preventing overload from overheating from shooting fast or from using enclosed soft boxes (specially designed enclosures containing one or more flash heads) where heat build-up could be a problem. The flash heads are also much lighter in weight than self-contained units, since they house only the flash output lamp and modeling lamp. This is a significant factor when suspending one from a boom or relatively high light stand. If you have a need for four or more heads, the cost of one studio pack with four heads is usually less than that of four self-contained strobes of comparable power, as is the total weight and storage space, as well.

The biggest disadvantage of a studio pack is its all-eggs-in-one-basket concept; if the pack fails, you're out of business.

There is also the limitation in positioning the heads, as their placement is determined by the length of the connecting cables. Cable extensions are an option but at an additional cost, and there can be some loss in output over the distance of longer extensions. With studio packs, every time you add a flash head to the pack, the power distribution per head is changed. Light output is referred to as watt-seconds, so if you buy a pack with 1200 watt-seconds capacity, that rating is for one head only. Add a second head, and you're down to 600 watt-seconds per head, while a third head makes it 400 watt-seconds/head. This power output can be varied with many of the brands available, in terms of symmetrical or asymmetrical output. In other words, this distribution of power output can be evenly or unevenly distributed between the number of heads in use. This is helpful when one flash head requires less light output than another, for example a background light versus a main or fill light.

Self-contained units are a less expensive way to start up a one-, two-, or three-light studio. They don't limit you in terms of placement on the set since they can usually be triggered via built-in slave/firing mechanisms from a primary strobe. You can also make very small adjustments in the power outputs of each individual unit. But most importantly of all, you're not out of business if one fails. In addition, the maximum power rating of a self-contained strobe is always available from each unit.

Several years ago, I switched from power-pack style lights to the more predictable and controllable self-contained units. My reason for this was very simple. I didn't need the power of several thousand watt-seconds per head, and I truly needed and wanted the control offered by the self-contained units. It's second nature for me to power my lights up or down individually with regularity, without thinking about the equipment. It works far more intuitively for me.

As with most things in photography, every product has a reason to exist. You have to match up your needs with the right tools for the job. For ease of use and control, the self-contained strobes get my vote. But for sheer power output, the power packs might win.

This VISATEC strobe, known as a mono light, is also manufactured by Bron Elektronik. It is well known for its durability, consistency of output and color, diverse series of accessories, ease of use, and considerable value.

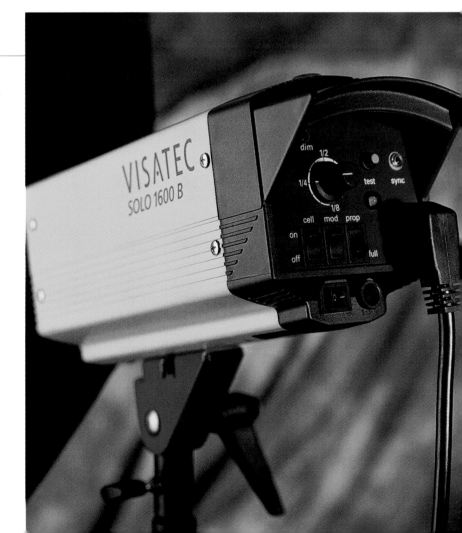

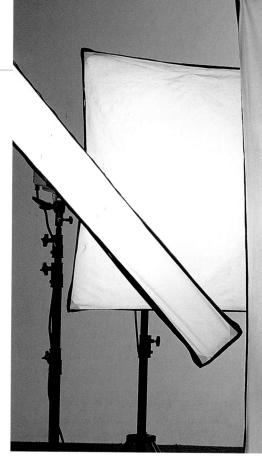

Soft boxes come in a variety of shapes and sizes that allow not only complete control of light quality but diversity in effects. The strip light (left) is ideally suited for accent lighting, while the larger boxes (center and right) work well in portrait and product photography.

Light Modifiers

THE CHIEF REASON for using a light modifier is to shape and then control direct light from a strobe head to produce a desired or needed effect. Since the size of a light is so critical to its effect on the subject, light modifiers are generally organized into the following three groups:

1. Those that enlarge the size of a source, such as soft boxes (flash head enclosures), umbrellas, and diffusion panels. These are most often used as both main and fill lights in portraiture as well as commercial product photography. In addition, their large field of illumination makes them ideal for evenly illuminating a background. Some can also function as larger accent lights, such as in rim lighting the outline of a subject.

2. Those that restrict the source, such as snoots and grid spots. These are better suited to accent and background lighting or for special effects. Other applications include adding a splash of light and color to any dark area of a photograph.

3. Those that reduce or eliminate light, such as scrims and gobos. Scrims (diffusion panels) reduce the light intensity in a portion of the light field. Gobos (large, rectangular, flat umbrellas) block and absorb light to protect against stray light effects on the set or in the lens.

Black or opaque gobos (go-betweens) are important for blocking light from a specific area in a picture, while scrims diminish brightness from a given light source. Both tools are vital to any full-service photography business.

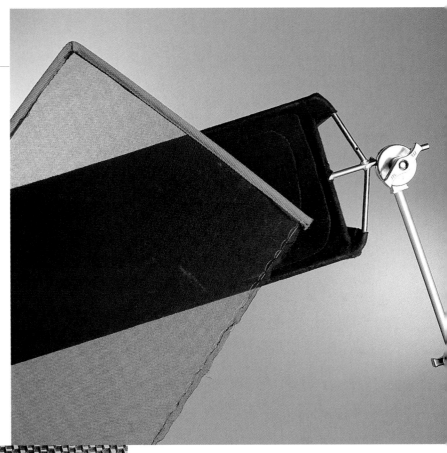

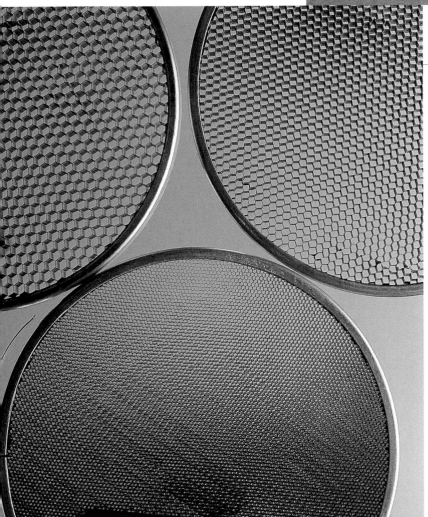

A grid spot, spot grid, or honeycomb—the name varies by brand— is one of the most important tools in the studio. Light is very directional when fired through a grid spot and is reduced to a beam that is directed by the size of the openings on these light modifiers. Shown at left are fine, medium, and coarse spot grids. Some manufacturers use 20, 40, and 60 degrees in their descriptions.

Different light-shaping devices and flash heads produce completely different results. The choices for photographers vary greatly and offer a solution for almost any given lighting challenge. While grid spots narrow the beam of light, optical spots focus the light. While soft boxes contain the light, umbrellas disperse it. Each has unique characteristics that the new photographer should explore and test. The diagrams here illustrate how each piece of equipment shapes and directs the light.

BARE BULB

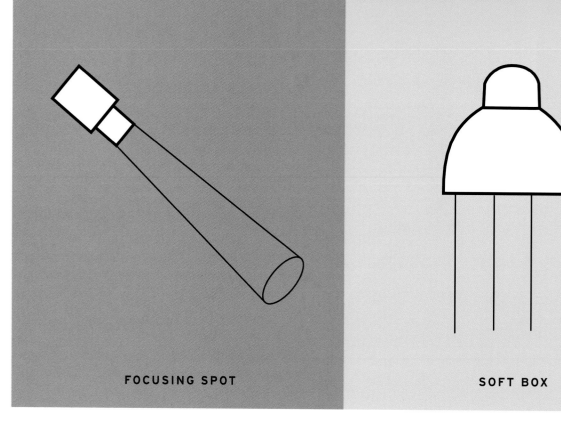

FOCUSING SPOT

SOFT BOX

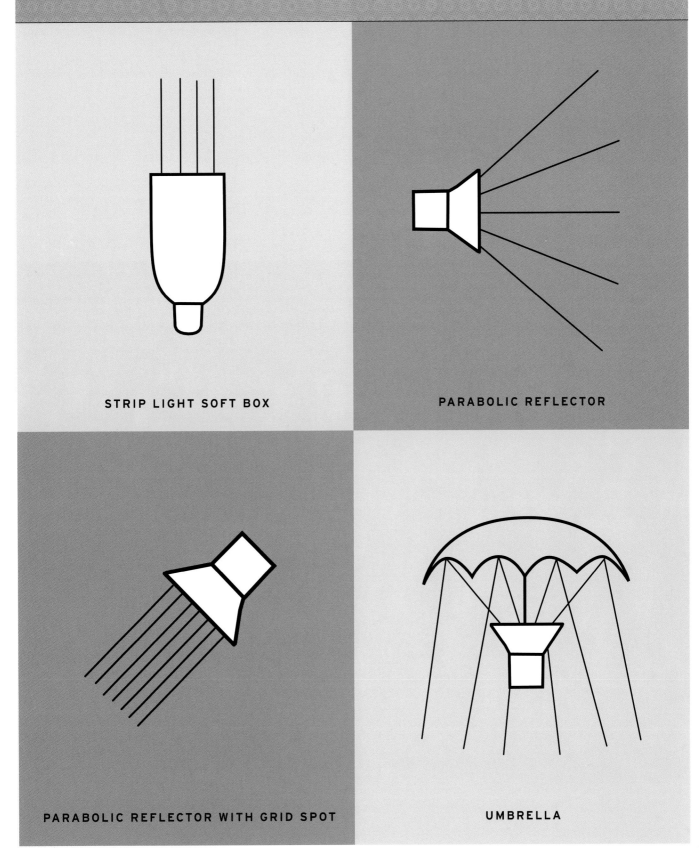

STRIP LIGHT SOFT BOX

PARABOLIC REFLECTOR

PARABOLIC REFLECTOR WITH GRID SPOT

UMBRELLA

Large-Field Light Modifiers

LARGE-FIELD LIGHT MODIFIERS are designed to increase the effective size of a given light source. They might be used to light a large area, but they might also be used to light a small object. The use is entirely subjective and based on individual photographers' styles.

UMBRELLAS

The most popular form of lighting umbrella has a strobe directed at its interior and enlarges the light field by the process of reflection. Manufacturers offer a variety of sizes as small as

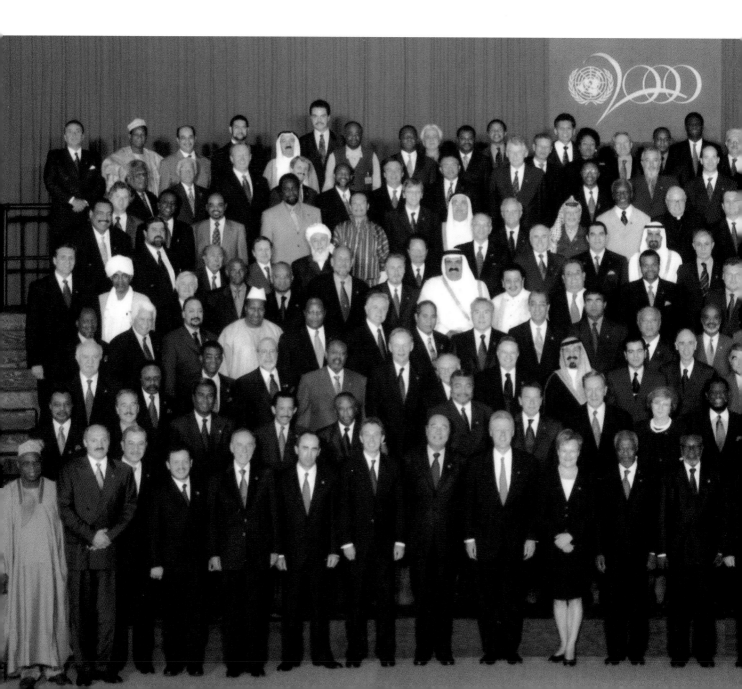

two feet in circumference to almost six feet wide. Typical sizes for studio portraits and small-product photography are about 40 inches, while you can use two or more of these (or larger models) to cover full-figure shots, groups, or backgrounds. All are as easy to open, close, and store as a conventional umbrella and usually mount onto the strobe by inserting the shaft of the umbrella into an opening provided on or near the light head.

You can control the field of light from an umbrella to some degree by changing where you place the strobe on the shaft. In general, the closer the raw light source is to the surface of the umbrella, the smaller the light field and the more likely that field will have a "hotter center" with light dropping off quickly at the edges. Reflection umbrellas vary significantly in their inner surfaces, from flat white to a variety of silver and white, as well as gold, materials. In general, the smoother the surface, the more efficient the reflection and the more directional the light (the more apparent the light direction is).

Silver interiors that resemble foil surfaces are the most efficient but often result in harsh, mirrorlike reflections of the flash. A flat white surface is the least efficient, giving off the

I shot this United Nations Millennium Summit 2000 group portrait of 185 world leaders with Terry Deglau of Eastman Kodak, using umbrellas, which are ideally suited for lighting large areas or large groups of people. Umbrellas evenly send light over large areas minimizing shadows and directional look. The even lighting assures the photographer of lighting each face well.

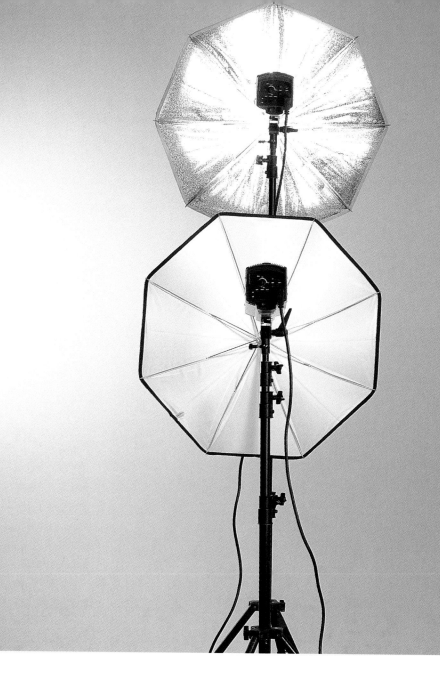

most diffused field of light. Umbrellas with combinations of white and silver surfaces are the most popular since they have an efficient surface yet without the mirrorlike reflections of smooth silver. Gold-lined umbrellas will significantly warm the color temperature of the light, giving effects similar to warming filters. Some reflection umbrellas have a black back fabric, which doesn't improve the efficiency of the interior reflection but does prevent any diffusion of light passing through the umbrella, making sure you get the most power output possible.

There are also several specialized forms of umbrella lights. *Shoot-through* models, for example, are used in the reverse position from reflection types, being pointed directly at the subject. The source light is scattered and diffused across the umbrella surface as it comes *through* the fabric, which acts like a curved diffusion panel and further diffuses the light as it reaches the subject. This type of umbrella allows you to position the light very close to the subject, and creates a completely different look than traditional reflective umbrellas.

SOFT BOXES

All soft boxes are designed to enlarge the effect of a small light source by reflecting its light off its internal surface sides and then diffusing that light through a translucent fabric front "skin." The result is a more even field of light than most umbrellas can deliver and more control over the direction of the light field. To help ensure an even field of light, some soft boxes employ an internal baffle set in front of the raw light source that first enlarges the light before it reflects and diffuses through the face (the fabric front). A black housing prevents light leakage, and some soft boxes have recessed face fabric to reduce spill while others have flush-mounted faces for wider coverage.

Soft boxes come in all sizes. The typical soft box sizes for studio work will vary from 3 x 4-foot versions for portrait and small-product work to 5 x 6-foot for full-length photography. As with umbrellas, there are different internal surfaces, such as silver and white, and some styles will even let you change the surface material, for added warmth for example. Many soft boxes have front fabrics that you can remove to convert them into a kind of "umbrella box."

Soft boxes are usually made of fabric with four or more rods serving as an internal skeleton to hold the shape of the box. These rods are inserted into a bracket called a speed ring that then attaches to the strobe. While some rings will fit more than one brand of strobe, you usually have to buy the ring that will fit your model. Soft boxes collapse into long bundles and can be stored in their own bags for easy travel. They should set up very quickly and be durable enough to withstand a lot of use if used for location photography.

The shapes and designs of soft boxes vary greatly and there are even a small number of extra-large models that have rigid housing, such as fiberglass with a Plexiglas face. The soft box

Most soft boxes or light banks are similar in design. They all work with a "speed ring" into which four rods are attached, forming the structure of the box.

design lends itself to a wide range of configurations and the use of a number of face accessories to control the light field even further. Examples include tall, narrow strip light boxes, hexagonal and octagonal boxes, as well as the common rectangular shape. Another example of a specialized soft box is the translucent style, which replaces the black side housing with translucent material for a very wide field of light. This design is especially effective at lighting a room interior.

A circular piece of fabric placed over any rectangular box will produce a round highlight in the eyes of the subject (also called a catchlight) in a portrait or fashion close-up, while a strip shape piece of fabric will mimic the narrow strip light soft box. There are also grid/honeycomb inserts made of fabric or metal that restrict the angle at which the light leaves the face or skin of the soft box. Such grids are especially effective at preventing light spill onto backgrounds, allowing those areas to be illuminated without any interference from the main light. Still another option is to use barn doors or louvers to restrict spill.

All of these features combine to make the soft box the most versatile light modifier in the studio today, producing the most even field of light and offering an extraordinary amount of control over the shape and direction of that field. In addition, a slightly warm or cool filter or gel over the front fabric of a soft box can dramatically and very easily change the mood of a picture.

On the less desirable side is the fact that soft boxes are expensive, especially for larger models in general and the rigid types specifically. They also require more setup and breakdown time. However, if the largest percentage of your work will be in the studio, a good quality soft box will be well worth the investment.

LIGHT SOURCE SIZES

What constitutes a large, medium, or small light source? Although there are no hard and fast rules defining "large" and "small" when referring to light modifiers, studio photographers think of the size of a light relative to the size of the subject. Thus, a 3 x 4-foot soft box used to take head-and-shoulders portraits would be considered the same size as the subject, and that would be considered a medium-to-large light source if positioned close to the subject.

However, it's important to remember that this rule of thumb applies only when you position the light close enough to the subject so that most of the light field actually strikes the subject. If you move this light modifier a few feet back from the subject, a good portion of the light will miss the subject. Thus, the effective size of the light will decrease as you move away from a subject.

In general, the smaller a light source, the darker the appearance of the shadows and the more likely you are to produce bright, overexposed reflections off a smooth surface. This constitutes a look typically characterized as harder because of its higher apparent contrast. (See chapter 3 for a more complete explanation of why the size of a light is so important to the final effect.)

The VISATEC Softlight Reflector is a perfect mix of standard reflector head and softer, larger light source. Available barn doors clip on the sides for additional control and light-"feathering" capabilities.

SOFT-LIGHT CIRCULAR REFLECTORS

In recent years, a number of large, rigid circular reflectors have stirred up interest among studio photographers. Basically, these units fit over the strobe like a standard bowl or parabolic reflector but are big enough to produce large, uniform light fields that can be used effectively in portraits and small-product shots. Typically, they measure 16 to 20 inches in circumference and most have either a baffle arrangement in front of the strobe or a translucent face like a soft box.

A lighting panel, such as this Bogen Lightform P22, is useful for a variety of applications. By selecting the type of panel fabric, you can use the panel to reflect or block light, as well as to allow light to pass through (as is the case with translucent fabric).

DIFFUSION AND REFLECTOR PANELS

Diffusion panels increase the effect of a light source by scattering the light from the strobe as it passes through the panel's surface, much like a cloud does when it moves in front of the sun. It literally spreads the light over a larger area. Diffusion panels come in large, freestanding, $3\frac{1}{2}$ x $6\frac{1}{2}$-foot sizes to smaller 2 x 2-foot versions that are held in front of a light source by a bracket. Since most studios use freestanding panels for a variety of functions, and since the cost of diffusion or reflector panels amounts to just the cost of the fabric, these are the least expensive of all light modifiers.

The size of the light field is determined by the distance between the light source and the panel surface. A light held very close to the back of a panel will have a small field with a hotter center. Pulling the light back a couple of feet enlarges the field by lighting more of the panel and reduces quite a bit of the light falloff. You can, therefore, produce small to large fields of light from a single, relatively inexpensive, freestanding panel. This is one of the primary differences between a diffusion panel and a soft box; the ability to adjust the distance from the light source to the front skin or fabric gives added control and choices in light quality.

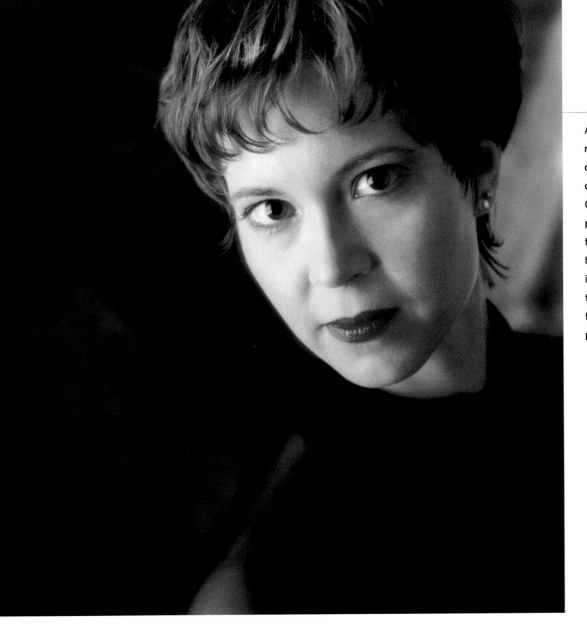

Adding a white reflector completely changes the mood of a photograph. Once again, this simplistic approach to filling in shadows has many benefits including low cost to own, ease of use, functionality, and portability.

Lightform was the first of these types of products, developed in 1984 by Dean Collins. He felt there was the need for a collapsible, lightweight system to control light. Since his original design, several other companies have started making light control panels.

Reflector panels, which have opaque reflective surfaces, enlarge the effect of a small light source by simply reflecting the light onto the subject. They bounce light into areas of a subject that are in shadow, controlling the contrast in the resulting image. The same principles concerning reflections that we discussed for umbrellas (on pages 52–54) apply when it comes to the efficiency of reflector panel surfaces and colors. In addition, black fabrics are often used to convert a reflector panel into a large gobo, adding contrast to the subject by reducing light on, or subtracting light from, one area instead of adding light.

Reflectors come in a wide variety of sizes and shapes; many are meant to be handheld, while others are mounted on a light stand with a support rod or clamp. Generally speaking, the smaller models are used as fill panels in combination with a main light, while the large, freestanding models are more likely to be used with a strobe as a main light source.

Diffusion and reflector panels are sometimes mistakenly thought of as the least controllable of light modifiers. The main problem is that they often allow light to spill over and around, since the raw light is not enclosed as it is in the body of an umbrella or within the housing of a soft box. In the case of a diffusion panel, some of the light will also reflect back off the diffusion material. In a small studio or on location in a small room, this raises the problem of contamination in the shadow areas. However, you can deal with this by setting up one or two gobo panels to enclose the light source, creating a large light chamber. This makes large inexpensive light sources easy to obtain.

The only difference between these photographs is in the shadow density. By quickly and easily adding a white reflector, you can see the exact results even before taking the picture.

The subjective decision on what makes a good portrait is entirely up to the photographer. What is important to remember is that every aspect of the picture can be controlled; darkness or shadows, again, are reduced by a simple white reflector.

This is a black light-subtractive panel, which diminishes light on one side of a product or subject, increasing contrast. This type of tool also works well for preventing stray light from reaching the camera's lens.

You can achieve interesting and unusual backgrounds by using an old Hollywood tool called a *cookie*. A cookie is nothing more than a surface with numerous holes, in different shapes and sizes, that allow light through. The distance from the cookie to the background and the distance from the light source to the cookie, along with your selected depth of field on the camera's lens, will determine the sharpness of the projected patterns on the background.

OTHER LIGHT-MODIFYING ACCESSORIES

There are a few other light modifiers of which new studio photographers should be aware. Studio strobes are basically bare bulb sources that spread light in all directions. Generally, a parabolic or bowl reflector is attached to the bulb to direct this light in one general direction. The parabolic reflectors that come standard with strobes are between 5 and 10 inches in circumference, which restricts the light to around 60 to 100 degrees. There are also special shallow collar reflectors, resembling flat metallic donuts, that send the light out over about 150 degrees when used in umbrellas or soft boxes. Barn doors also restrict the angle of the light from a strobe and usually come with their own mounting brackets to allow for varying the angle of the light.

The primary function of snoots and grid spots is to deliver a restricted circular field of light. Snoots are nothing more than tubes with diameters of about four to eight inches that fit over the light source. Grid spots (page 49) are more refined in their control. These devices take a number of different mesh or grid attachments that narrow the angle of the light to deliver different size patterns or "shafts" of light (also see chapters 1 and 3

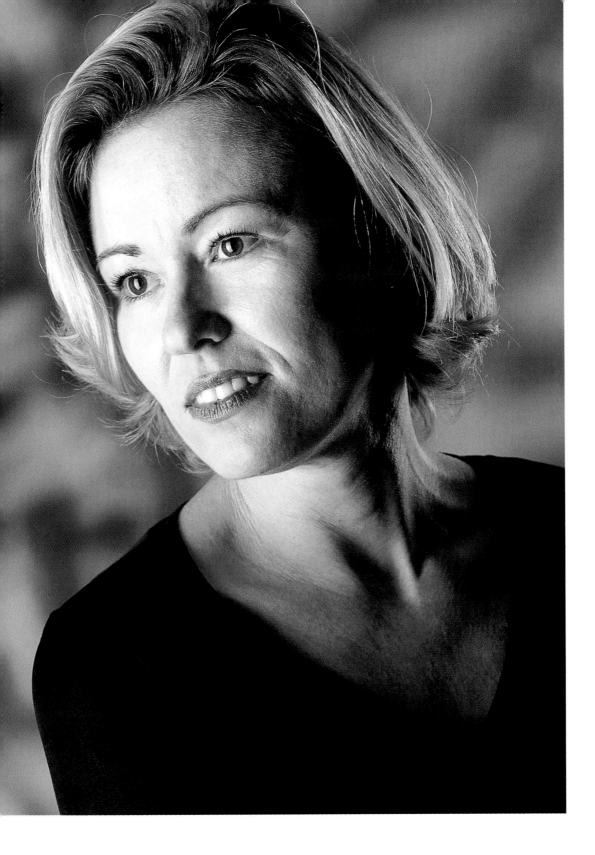

for more on backgrounds and accent lighting). Grids are identified by the degrees of their restricting angle, with the smaller numbers indicating a tighter pattern. They generally come in three sizes or degrees, ranging from fine to medium to coarse.

Neither snoots nor grid spots should be confused with more expensive optical spots, which use their own lens systems to focus the light into a very tight pattern. As such, it's possible to use *insert fronts* with cutout patterns and project these focused patterns onto backgrounds, producing, for example, shadows of window blinds or tree leaves.

A light that can be focused to a small circle, or any other desired shape, is always helpful to have. Many different brands are on the market, and while they may vary in features, their design is basically the same. An internal lens (or lenses) literally focuses the light as it passes through the optic. This allows the mimicking of any shape placed inside the light's aperture.

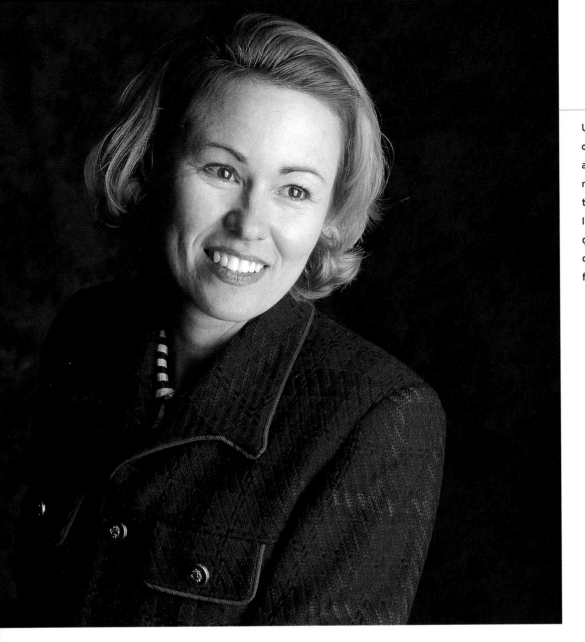

Using a black reflector or "absorber" will offer a greater contrast range and control. Due to the ability to literally "see" what you're getting, placement of the black panel or fabric is fairly simple.

SCRIMS AND GOBOS

A scrim is usually a tightly strung piece of mesh material that is placed in front of a light source in order to reduce intensity. Scrims come in various shapes with appropriate names: for example, fingers and dots. One of the most common applications of a scrim is to reduce a portion of the light's intensity within a section of the light field. For example, to reduce the amount of light striking the surface of a bald head (and thereby lower its prominence) you might use a scrim between the accent light and the subject.

A gobo or "go-between" is any dark (almost always black) surface that completely absorbs or blocks the light that strikes it.

Gobos come in a wide range of sizes and forms. They can be large 3 x 6-foot freestanding black fabric panels or pieces of flat black foil wrapped around a chrome light stand to prevent reflections. One of the most frequent uses of a gobo is to prevent light from hitting the front of a lens, which might cause internal flare if lighting on the set is directed toward the camera.

LIGHTING GRIP

In addition to light sources and light modifiers, an efficient studio needs a range of appropriate lighting support equipment or grips, specifically light stands, light booms, and freestanding panels.

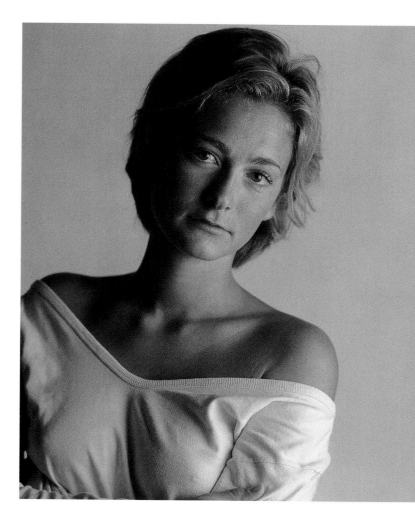

Continuous Light vs. Electronic Flash

ANOTHER VERY IMPORTANT ASPECT of understanding lighting and all the options available in the studio deals with a continuous light source. This source of light will differ from the studio strobes/flashes in several ways. Most significant is the exposure necessary to utilize almost any light other than flash. If using tungsten or "hot" lights the exposure time will be quite different than when working with studio flash.

Before discussing how to use these lights, let's first discuss why someone would choose to work with lights that obviously will require slower shutter speeds and possible color correction. The reasons are fairly simple. First, a shutter speed not only freezes action by stopping movement, it can also blur action, implying motion. In other words, by slowing down a shutter speed the photographer can introduce *time* or motion as another element in an image, in addition to three-dimensionality.

In addition to implying motion by utilizing time, try to keep in mind that this book is about the photographer being in control. Control should offer other solutions. Consider the example of when photographing a subject or object that isn't moving. A long exposure has no actual bearing on the final outcome of the image. This allows the photographer the ability to "burn" in an exposure on just about any subject.

I use hot lights almost always when copying flat art such as photographs. I also use hot lights a large percentage of the time when shooting small products. By adding the element of time to my exposures, I gain the added benefit of being able to do things during the exposure that are impossible during the instantaneous exposure duration when working with flash. Adding an accent to a small dark area of a product, using a flashlight, can be a great help to still-life photogra-

Using a continuous light source on the background, as in these two pictures, allows the photographer to be creative by "burning in" the exposure on the background while the flash "freezes" the subject. The "motion" in the second image, is the result of simply shaking the camera *after* the flash froze the model and while the continuous light source was still making an exposure behind her. The exposure was 4 seconds at *f*/5.6. Note that the modeling lamp on the flash *must* be turned off in order to maintain proper exposure on the subject's face during a long exposure like this.

phers. Another technique is the actual shaking or moving of a background during an exposure, thus allowing it to appear out of focus by not registering on the film. When do you use hot lights and when do you use flash? It all depends on what you're photographing and how you intend to portray the subject.

In order to determine exposures with "hot" lights the light meter must be set to *ambient*, as if you're working outdoors. The average brightness of the light falling on or striking the subject would require the exact same incident light measurement required with flash. The main thing for the photographer to consider is the amount of time necessary for any desired or needed working aperture. The small aperture will obviously require more time for the exposure. This can be a benefit or a hindrance depending on your situation at the time.

PRINCIPLES of

What does light control mean and why is it necessary? From the moment a photographer takes his or her first picture, light plays a key role in the success of that image. Amateur photographers generally face one concern: Is there enough light for the picture to "come out"? This is important for professional studio photographers, as well, but it's not the only concern. Light has to perform several functions other than just lighting a scene. It creates texture, relates emotion, defines shape, builds drama, adds excitement, and communicates dimension. Light is responsible for most things people "read" into a photograph.

Light Control

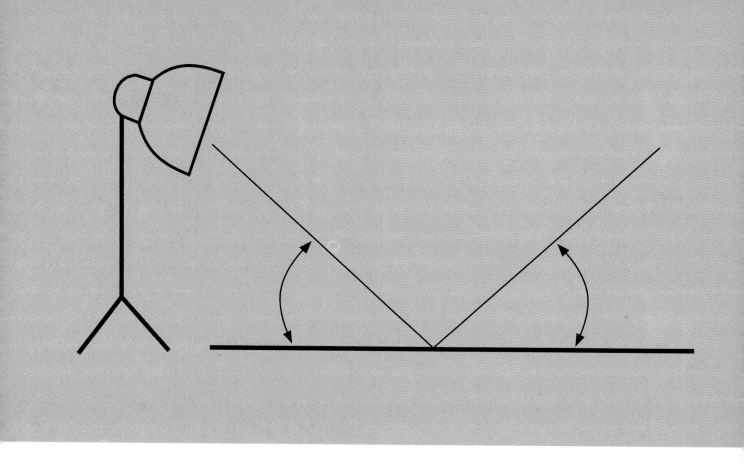

Angles of Incidence and Reflectance

WHEN LIGHT STRIKES A SURFACE, it reflects off of that surface in the exact same angle or direction that it struck the surface. This is the well-known photographer's law that says: *The angle of incidence equals the angle of reflectance.* While this may seem simplistic to some, it is one of the more important aspects of lighting. By knowing how light reflects, you can know how it strikes, and therein lies one of the principle keys to lighting success.

How should light strike the surface, and where will it reflect? Think about a picture of a balloon. Photographing a balloon is an excellent way to witness the principles of light in action. While a seemingly simple product, a balloon reveals how light reacts when striking a highly polished, shiny, round surface. It shows the differences in the reflections resulting from a large light source or a small one, including the direction, the color, and the placement of the shadow relative to the reflection or highlight. And it shows which type of lighting creates the most depth and dimension.

The angle of incidence
equals the angle of
reflectance. All photo-
graphic books and
periodicals discuss
this lighting theory.
It means that as light
strikes any smooth
surface, it bounces
off that surface at the
same angle as it hit it.
Some textured or
otherwise unsmooth
surfaces, however,
reflect light differently,
often scattering light
as it bounces off.

With a small light
source, notice
the brightness and
size of the highlight
and how rich the
color appears.

As the size of the light
source increases, the
highlight diminishes
in brightness and the
shadow on the surface
becomes softer. The
subjective nature of
photography often
allows you, the photog-
rapher, to choose the
size of the light
source. By understand-
ing the size-to-distance
relationship (see
chapter 2), you can
make these choices
quickly and easily
and accurately attain
predictable results.

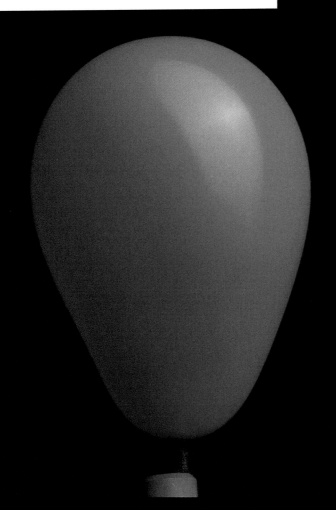

In portrait photography, the large window can offer the same light qualities as a large soft box: soft shadows, lower contrast, and diminished specularity in the highlights.

Light Size and Quality

THE EFFECTIVE SIZE of any light source is always relative to its distance to the subject and relative also to the size of the subject. A 3 x 4-foot light box is a rather large light source when placed three feet away from a person's face. However, when placed 15 feet away, it becomes a much smaller light source. The difference is in how each *relative size* creates and identifies highlights and shadows on the subject.

You also have to factor in the size of the subject being photographed. Is it larger or smaller than the light source? The size of the light source then becomes relative not only to its distance to the subject, but also as compared to the size of the subject.

Using a window as the primary light source offers a good example. Window light is generally thought of as soft light. This is because the light is usually nondirectional and low in specularity (see page 74), and generally creates a soft, pleasing photograph. However, if you move your subject further away from the window, more into the room, the effective size of the light source "diminishes" and becomes a hard light, no longer producing the soft, pleasing attributes a nearby window can provide.

Among the different light sources, there are many choices in shape, quality, and of course, size. In light boxes alone there are sizes ranging from 1 x 2 feet all the way to 20 x 30 feet. It's all a matter of the desired or necessary effect, and while it may be hard to believe, each option has a right to exist. In other words, there are as many different light-shaping tools as there are applications for their use. Almost every product developed in photography is the result of photographers needing that particular tool and then either developing it themselves or having it developed by someone else. Either way, the photographer is credited with most innovation in our industry.

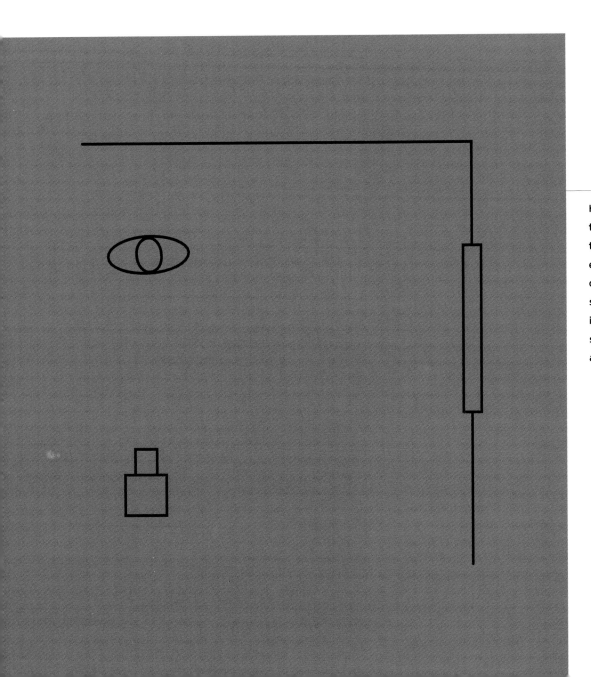

However, as the distance from the subject to the window increases, the effective size of the window (or light source) diminishes, increasing specularity, sharpening shadows, and raising contrast.

Specular Highlight Control

A SPECULAR HIGHLIGHT can be defined as a mirror image of the device that created the highlight. For example, a "catch-light" in the eye of a subject is a mirror image of the light source. Let's look a little more closely at what happens as the size of a light source changes. As the size of a given light source either gets larger or is moved closer to the subject, the highlight becomes larger and is spread over a larger area. The larger the area the highlight covers, the less intense the highlight becomes. As it becomes less intense, it decreases in brightness while its size increases. (Take a look at the balloons on page 71 again.)

To put it another way, the size of any reflection will increase as a light source increases in size (or is moved closer to the subject), while at the same time the brightness of the reflection of that light source will diminish. The rate at which the brightness diminishes is the exact same rate that its size

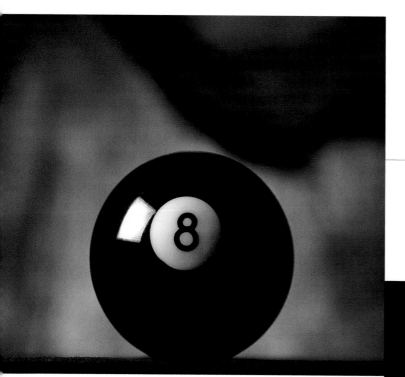

A larger source reduces specularity, diminishes shadow sharpness, and renders the picture softer overall.

A good example of the size-relative-to-distance theory of light sources, a smaller (or more distant) light source produces a highlight that's small, bright, and very intense.

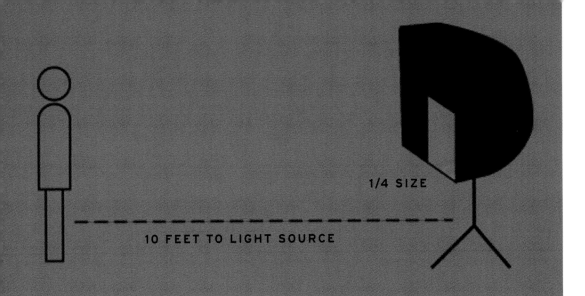

1/4 SIZE

10 FEET TO LIGHT SOURCE

According to The Law of the Inverse Square, the size of a light will become $\frac{1}{4}$ its size when its distance to the subject is doubled. It essentially becomes smaller by $\frac{1}{2}$ vertically and half horizontally because light falls off (or becomes smaller) inversely by the square of the distance. If a light source that is 5 feet from a subject is moved away to 10 feet, the effective size of the light reduces not to $\frac{1}{2}$ its original size, as the distance might suggest, but to $\frac{1}{4}$ of its original size. By learning this law, photographers can accurately adjust and predict changes in exposure, recognize subtle differences in lighting, and generally have a fuller understanding of how light reacts to almost any surface.

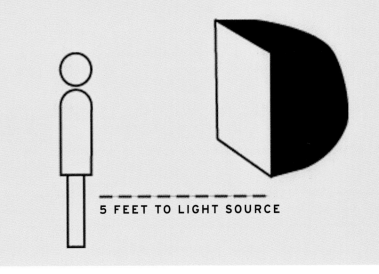

5 FEET TO LIGHT SOURCE

increases. This is governed by a law of physics called The Law of the Inverse Square, which states that light falls off or diminishes by the square of the distance as a light source gets smaller (as the distance doubles, the light source diminishes by $\frac{1}{4}$). Don't get concerned about the light being too bright for the subject as it gets closer to the subject, or too dark as it gets further away. Metering and proper exposure techniques will take care of the subject's brightness, and we'll discuss *quantity* of light in the next chapter. This is *quality* of light we're considering.

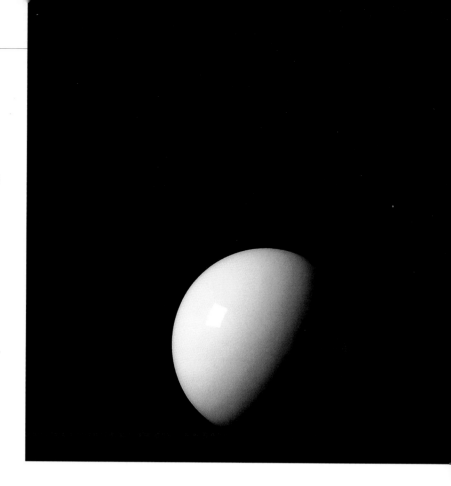

Not only are shadows more easily seen on lighter-toned subjects, but the size of the light source again becomes a factor. Here, a small light source was used to produce the concentrated reflection highlight and sharp shadow edge.

Shadow Edge Control

CHANGES IN THE SIZE OF A LIGHT SOURCE affect not only the brightness and size of the reflections, or specular highlights, but also the edge of a shadow. The smaller the light source, the sharper the edge of the shadow; the larger the light source, the softer the shadow's edge.

What some photographers were never taught is that these two indicators of a light's size are linked together. You cannot change or in any way alter the edge of the shadow without also changing or altering the size, and therefore the brightness, of the reflection or highlight. The two go hand in hand and must both be considered any time a light is moved either closer to or further away from the subject. This is a rule of physics, and while you can bend and even break some rules in photography,

physics is physics. I often see photographers casually moving lights closer to and further away from their subjects in studio situations. This is fine, as long as it's understood that in changing the light's distance, therefore its effective "size," relative to the subject, you also change the highlight brightness and size. And, in changing the highlight brightness and size, the shadow edge is also changed.

We'll discuss the brightness or darkness of shadows later, but keep in mind that the size and distance of a light source relative to a subject does not affect the density of the shadows as much as some might think. The density of a shadow is largely controlled by the ambiance, which is another control the photographer can utilize.

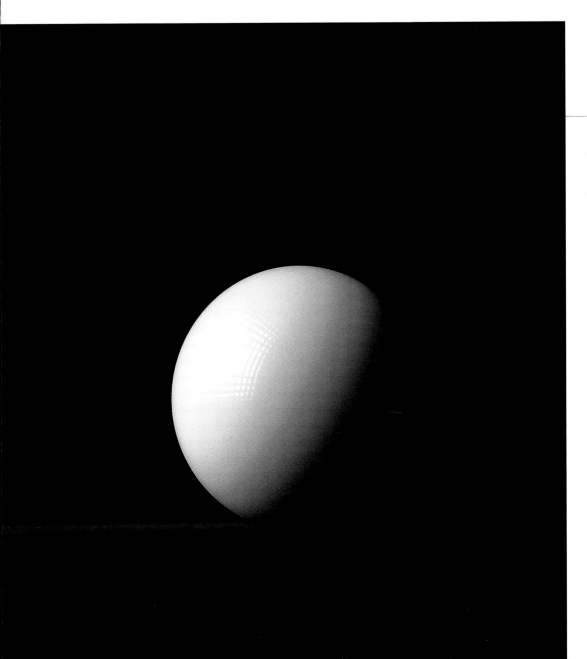

Increasing the size
of the light source
scatters the reflection
highlight and also
reduces the sharpness
of the shadow's edge.

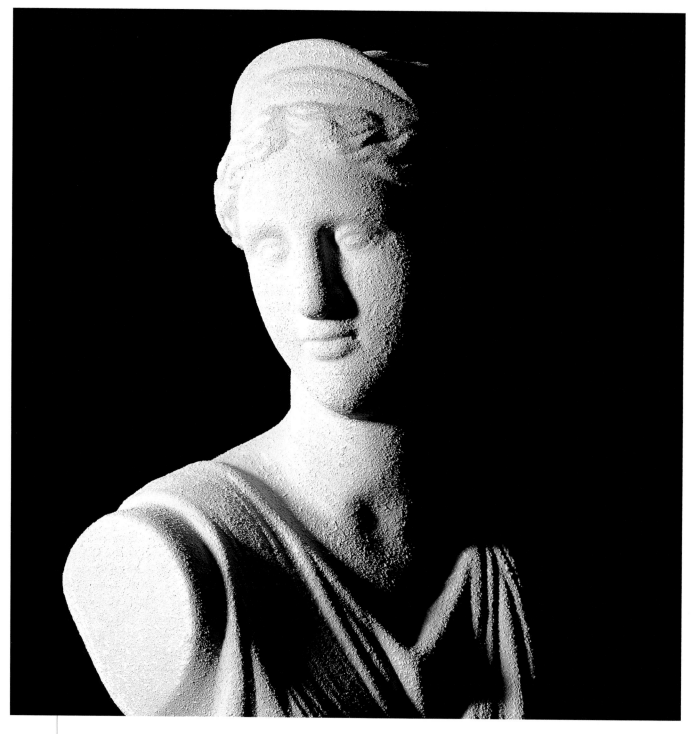

Notice the sharpness
of the shadows and
how much more texture
can be seen when using
a small light source.

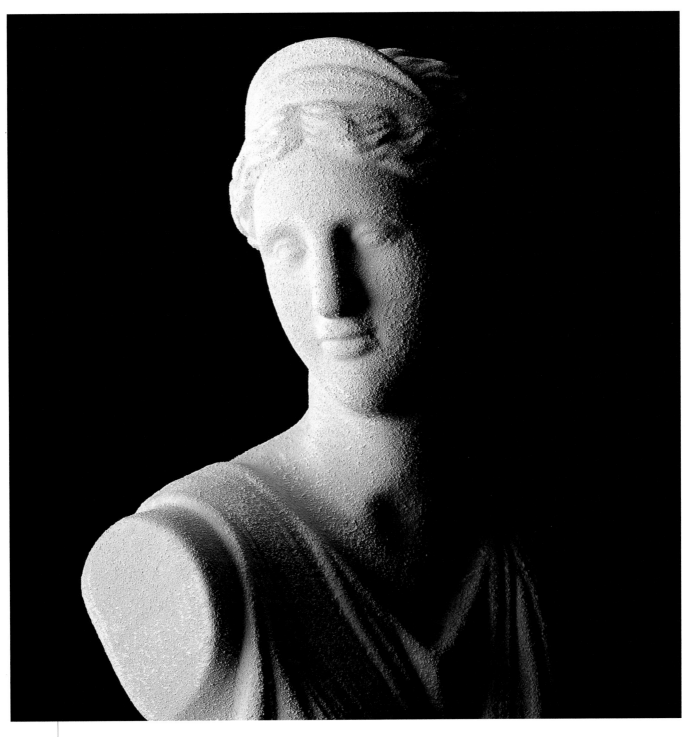

As the size of the light
source increases, the
shadows becomes soft-
er, revealing less tex-
ture than is seen with
the smaller source.

Highlights

HIGHLIGHTS CAN BE SOFT and diffused or hard and specular. A specular highlight can be defined as a mirror image of the lighting device that created the highlight. For example, on a smooth or shiny surface you can clearly see the exact source of light used to take the picture; you can also determine the type of light source used, its size and/or distance to the subject, and often guess the aperture used to take the picture.

A reflection is exactly that: a reflection. Therefore, when looking at a reflection, you're looking at a mirrorlike surface and, remember, focus is accumulative. This means that you might have a close-up of a face with out-of-focus catchlights (reflections of the light source in the eye), or if the catch-lights are in focus, the eye itself could be slightly out of focus. It's all based on a lot of factors, such as lens focal length, film format (size), working aperture, and the camera's distance to the subject.

Diffused reflections or reflections from a large or nondirectional light source help identify the subject and relate all of the information the viewer needs in order to ascertain the message of the picture. These highlights usually hold detail in their brightness, and are not pure white without detail, as in some cases when smaller lights are used. The shape and color, and tonality and texture are all easily identified by the diffused highlights.

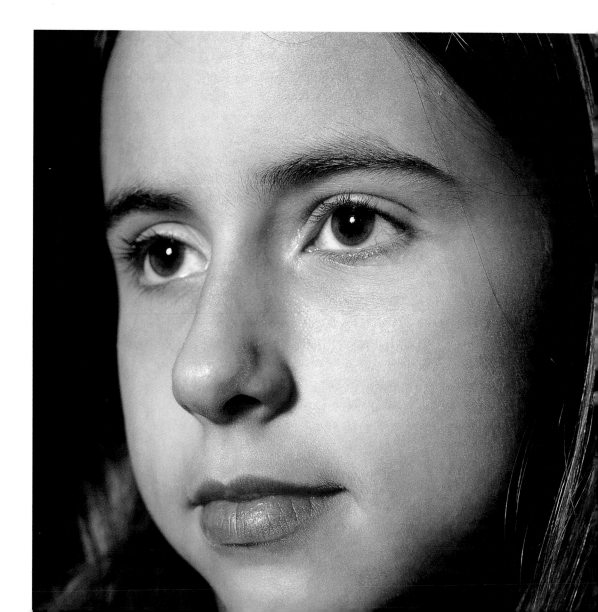

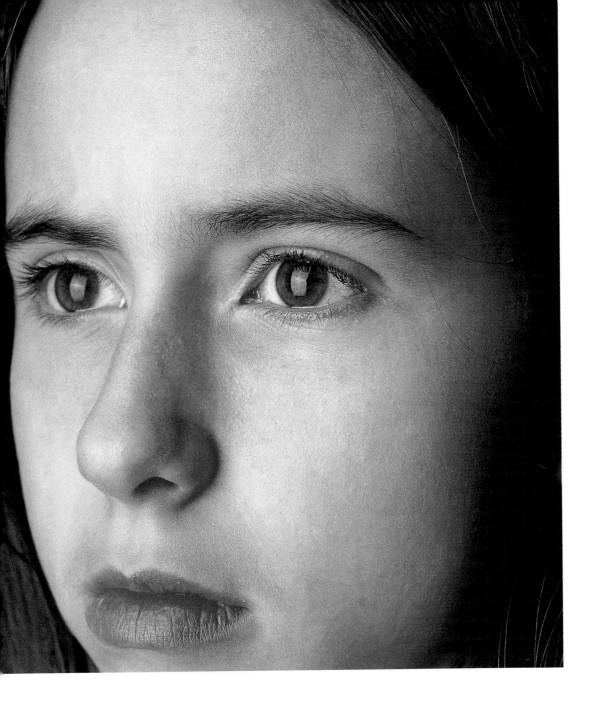

This close-up portrait opposite, lit with an umbrella, illustrates the reflective nature of the human eye and how it will always reveal what lighting the photographer used. The same picture above, lit with a large soft box, results in a completely different look to the eye. One isn't correct and the other wrong. They're simply different, and the success of one over the other depends upon the desires of the photographer.

This photograph above of a Hasselblad 503CW camera taken with a small light source shows hard-edge shadows, high-contrast highlights, and is generally less than a client might desire (the color is the result of warming filters on all lights). The same picture taken with a large 80 X 160cm VISATEC soft box, opposite, completely changes the mood of the shot; the softer, more rounded highlights are apparent, as are the softer-edge shadows.

Controlled highlights are generally used and necessary on medium- and darker-tone subjects. In order to produce contrast on medium or dark subjects, you need the highlights and highlight control. Conversely, shadows are necessary in order to have the same identification effects on medium- and lighter-tone subjects. You can't easily use highlights to identify the shape and contours of a white car. It is shadows that create the contrast on light-toned objects, and this in turn identifies the shape and texture.

Specular reflections, highlights created by a small light source, are helpful in creating drama, elevating contrast, and adding a seemingly harder edge to your pictures. The smaller the light source, the harder the edge. This seems confusing to some. For example, in taking a portrait, some feel that as they look at the face of a person, they can back their main light away from the subject and visibly "see" the light quality get softer. On the contrary, what they're seeing is the result

of a trick on the eye. The eye thinks the light is getting softer because it sees the brightness diminish slightly as the light is moved back, while it also looks as though the room ambiance increases, allowing the eye to "see" more in the shadow areas. However, the shadow edge gets harder (when the light is moved farther away from the subject), building more contrast. The specular highlight gets brighter and at the same time, more intense.

So, the question is, What is the photographer suppose to do? Where should the lights be placed? Unfortunately, I can't answer that question. Or maybe I should say, I won't answer that question. This is where style, personal preference, mood, drama, and glamour are contributing factors. I think it is fundamentally wrong for one photographer to tell another how to light anything when opinions and subjective decisions are in many cases why people get into photography in the first place. I think my responsibility is to show you the effects of lights at various positions, and discuss and illustrate how lights react to given situations. I can illustrate a few setups and provide a few tips, but ultimately, it's up to each individual photographer to determine how to incorporate that information into the work.

MEASURING the

In every photograph, there exists an oppor-
tunity for creative decisions regarding
composition, lighting, and, when working
with people, posing. A photographer must
also decide on the importance of making
the subject being photographed appear as
it does in reality. In other words, there's a
decision to be made regarding the bright-
ness or exposure of the subject.

Quantity of Light

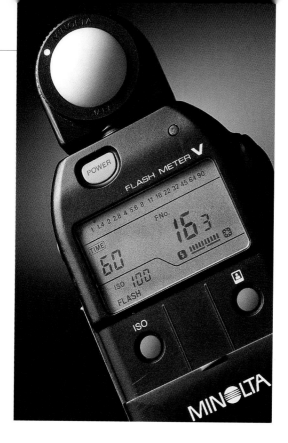

My light meter of choice is this Minolta V flash meter, which reads incident and reflective light. Here, it has the incident sphere attachment in place. (See lower left photo on page 88 for reflective attachment.)

Light Meters

THIS DECISION TO MAKE THE SUBJECT appear brighter, darker, or true to reality will often depend on a number of factors. If the photograph is a traditional portrait, reality, or the true tonality of the subject, would be very important in determining the exposure. When creating an abstract picture, the decision to overexpose the scene if it might enhance the image would be the right choice. Alternately, often when working with strong directional lighting, underexposure creates a feeling of drama. In every case, the photographer must make the decision based on his or her knowledge of film speed, lighting equipment, and how the subject reacts to the lighting equipment and the proper use of a universal tool: the light meter.

Light meters have been around for many years and have been designed to measure the amount of light falling onto or reflecting off of a scene or subject. With today's modern electronic cameras, most people can get a good or acceptable expo-sure by simply letting the camera make their choices. This is especially true for photographers using negative film, due to its design allowing slight over- and underexposures. For many outdoor and even some indoor applications, this works well. It also works well when you're using an automatic camera with a portable flash. But when working in the studio with electronic studio lighting, more careful attention to the exposure is essential if predictable results are important.

Many of today's *reflective* and *incident* light meters are available with ambient, or available, light reading capabilities, as well as flash metering. The modern electronic meters of today with LCD digital readouts and 1/10 *f*-stop accuracy do not closely resemble their predecessors with the needle that would go across the scale and stop at the right aperture or shutter speed. So, today's studio photographer must have access to all the necessary tools in order to work accurately, fast, and with any degree of predictability.

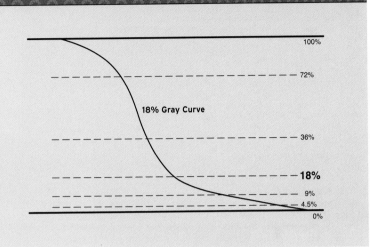

Middle gray, or 18% gray, is the mid-point of a logarithmic curve. The exponential science of photography prevents the mid-point from being at 50% gray. In photography, every number in succession is doubled from the previous number. For instance, the difference between 18% and 36% is one stop; 36% to 72% is another stop. Effectively, two stops open from middle gray (18%) is white with detail (72%). Two stops closed from middle gray (18%) would be black with detail (4.5%).

REFLECTIVE METERS

Reflective light meters are probably the most common types of light meters available largely because of the heavy influence of amateur or automatic cameras on today's market. These reflective meters, which include in-camera spot meters, are designed to read light *reflecting off or emitting from* any scene or subject as a mid-tone or middle gray. In photography this is called this 18% gray, and it is the mid-point on film between white and black. It's considered 18% instead of 50% due to the logarithmic scale from which everything in photography is based.

When you point a reflective light meter at a subject or scene, the meter will read or display a value that is the *effective* working aperture, based on the corresponding shutter speed and ISO or film speed. This will be correct if the subject or scene that the meter "sees" is of a mid-tone. Green grass, a bright red dress, and an average tree trunk all translate to a mid-tone when seen by a light meter. So, if you aim the reflective meter at these subjects, the resulting exposure will be correct as long as you follow the meter's given exposure reading. An 18% gray card, available at most cameras stores and photographic retailers, can be used as a tool or guide in taking reflected light readings. This gray card, when placed in the scene in the same light value as the subject, can be very helpful when the exposure of a particular subject is critical. However, anything a reflective meter "sees" that is brighter or darker than the mid-tone will render the photograph over- or underexposed (since it will cause the meter to see the overall scene as darker or lighter than it really is) and require an adjustment in the exposure in order to maintain the proper tonality.

To properly use a gray card for exposure readings in the studio, you must position the card on the same plane as the subject. It should be angled or placed so as to have no highlights or shadows that might *fool* the meter. Many photographers choose to laminate their gray cards with a glossy plastic coating or shiny packing tape so that when the card's position does produce a highlight or reflection, they will easily notice it. They can then move the card slightly until the reflection is eliminated, assuring that the tonality of the gray card is true, without highlight or reflection. The spot or reflective meter can then be aimed at the card, rendering a true exposure for the subject based on the amount or quantity of light striking the subject and reflecting off of the gray card.

The gray card at left is reproduced correctly. The colors in the strip are accurate and the true mid-point exists in the gray. The gray card below, however, has been tilted slightly toward the light source, revealing how easy it is to be off axis with the light, thereby *not* rendering a true 18% gray. The flat, nonglossy surface on most gray cards makes it easy to make this mistake. One solution is to laminate your gray cards with a glossy surface, making it much easier to see the highlight from a light source. Then you can simply move the gray card left or right until the reflection disappears and the true gray is what remains.

By removing the incident sphere and mounting an attachment called a 5-degree spot you can transform the Minolta V meter from an incident light meter into a reflective spot meter. The 5-degree area is a good size for determining exposure in almost any working situation.

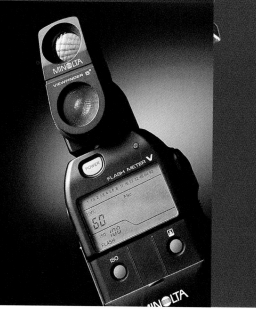

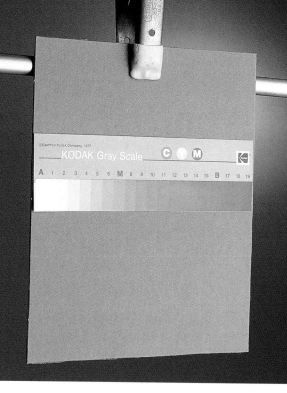

Reflective meters also read the amount of light emitting from a subject or object. For example, if you photograph a backlit sign at night, a bright flame or fire, or any other subject that is its own light source, a reflective meter will again render the scene or subject as if it's a mid-tone. The photographer's creativity or judgment, as well as the desires of the client, will dictate what, if any, adjustment is to be made.

Reflective meters are useful in the studio, especially when reading the value of light reflecting off of backgrounds or areas of the image where the photographer needs to know the actual brightness value as it relates to the aperture or exposure for the final picture. A photographer working with a reflective meter has the ability to read the precise amount of light in several areas of a scene in order to determine the amount of contrast in the entire picture area. This is of particular importance to commercial photographers who must think of the range of contrast and how their image will reproduce on a printed page. It's equally important to those working with reversal or transparency film.

Hasselblad's PME 90 Prism has the best of both worlds: It features spot and area metering as well as incident metering.

Working with reflective meter readings outdoors is by far their most common use, and sports, wildlife, and nature photographers will utilize the concentrated spot meter in their cameras to read only a specific area of a scene or subject. For example, there might be a certain grove of trees that appears as a mid-tone on film, and this would be the appropriate area at which the photographer would direct the meter. Those photographers shooting sports pictures might find a red uniform or dark orange windbreaker to use as a metering point.

The interesting thing about reflective meters is that when aimed at a white wall, they see it as gray. When aimed at a black wall, they also see gray. The good news about this is that the meters try to make everything they see 18% or middle gray. The creative photographer can use this information to his or her advantage, often doing not what the meter suggests, but opting for a measured distance or measured quantity of light away from the recommended settings. For example, if the reflective light meter is aimed at a black wall, it will "see" the wall as gray unless an exposure compensation is dialed in. However, the actual exposure the photographer uses can be adjusted to make the gray wall appear white or black or any tonality in between, based on the knowledge of how to make it gray. If a reflective meter tries to objectively make everything one tone, you can also use it subjectively to make that one tone *any tone.* Just remember that reflective meters are designed to "see" a mid-tone and you often need to make adjustments, therefore making reflective meters not exactly "automatic" meters.

INCIDENT METERS

Incident meters—meters with a diffused spherical dome usually positioned on top of the meter—are designed to render a scene or subject as it truly is. By reading the amount of light that falls on or strikes a subject, an incident meter will give a reading that, when adjusted for the proper film speed, can adequately render a scene or subject as its true tonality. I call the incident meter a reality meter. If you meter the light falling on a white wall, gray wall, or even a black wall, these walls would appear as they should, with their proper and correct tonality. It is for this reason that the majority of photographers working in a studio choose to work with the modern handheld incident meter. By measuring the amount of light falling on a subject, the photographer can make exposures with confidence, knowing that the meter will indicate what the exposure must be to yield the proper result.

Like the reflective meter, the incident light meter must be used properly if it is to give the correct exposure. The directions for most incident light meters suggest aiming the sphere toward the camera for a correct reading, especially when the light source, indoors or out, is at a slight angle to the subject. Some photographers feel that their exposures are more accurate and repeatable if they aim the sphere at the main light source, especially when the light is at more extreme angles.

Most portrait labs use a system of recording color data and printing densities on the back of proofs. This allows photographers to review all their exposures to evaluate how they compare to the lab's standard. Negatives are also individually marked with the same information.

I metered each light in this photograph with the dome of the incident light meter aimed directly at the light source, effectively placing "true tonality" on the film. True tonality can be defined as representing the subject as it should be.

Normal exposure on Kodak E100VS transparency film rated at EI 100.

INDIVIDUAL TESTING

Meters can be out of calibration, labs may process film differently, photographic papers react differently, and even photographic printers make adjustments when making prints from negatives that are slightly over- or underexposed. However, the single most important aspect of metering is that you must test your meters for your film, your lab, your lights, and your style of shooting. There is no objective basis on which all metering decisions must be made, nor should there be. Photographers should always have creative control over their exposures based on the personal objectives of their work, specialized use of films, desired effects, or clients' wishes.

FILM AND EXPOSURE

Fortunately for photographers, many of today's films have a built-in latitude, or exposure variance. For example, color negative film can easily accommodate underexposure by as much as 1 full *f*-stop and overexposure as much as 2 full *f*-stops without suffering problems in printing that cannot be overcome. Some films have more, some less latitude. Each of the major film manufacturers publish exposure recommendations based on objective tests in their labs and studios, and welcome the chance to talk to photographers about film ratings and specialized designs. In most cases, these recommendations are accurate. However, as mentioned earlier, testing for yourself is the only way to know with any real certainty how much latitude there is on the particular film you may be using based on your actual usage.

This exposure latitude is extremely important in instances in which simple mistakes are made and an image would otherwise be unusable. In the case of reversal, transparency, or slide film, there is very little exposure latitude in the film. The film is the finished product, whereas color or black-and-white negatives require another step—the printing. It's in this second step that photographers have the ability to change the effective exposure by over- or underprinting when working with negative film.

Plus 1, or 1 stop over-
exposure on the same
Kodak E100VS film
rated at EI 100.

Minus 1, or 1 stop
underexposure, again
on the same Kodak
E100VS rated at EI 100.

Color negatives have a much wider margin for error in exposures than transparency or slide film. At left is the correct exposure for this particular negative film, Kodak Portra 160 rated at EI 160. The same picture below, overexposed by 1 full *f*-stop, shows no problems in highlight or shadow areas that might make the negative unprintable.

It's important to note that film development has a major impact on exposure. It also has an enormous impact on the contrast of a scene or subject. A good example of this principle might be in the situation of a very low-contrast scene, such as an overcast day. When underexposing the film, the photographer can compensate for exposure by overdeveloping the film. It's during this overdevelopment that scene contrast increases, based on the increased development, resulting in a picture of more normal contrast than the overcast day might suggest. Of course, the opposite is true in the instance of a high-contrast situation, when the photographer has the ability to overexpose the film and underdevelop the negatives, rendering a scene with less contrast than normal. However, this process of overdevelopment *push process* and underdevelopment *pull process* requires much testing. This is especially true when color films are utilized and a change in the color balance, or color crossover, could occur. This is most often the case in the underdevelopment process.

When making decisions about the amount of exposure or quantity of light necessary for a given scene or subject, there exists the opportunity to creatively influence the final product by changing the viewer's opinion of reality. In many instances, photographers will shoot a variety of exposures to select from later. Referred to as *bracketing,* this is the changing of the aper-

Again, underexposure by 1 *f*-stop seems to have no real adverse effect on negative material. The built-in margin or latitude for exposure for negative films has saved many photographers' work in difficult metering situations.

ture or shutter speed to vary the amount of exposure. Some beginning photographers are often unsure of their exposures, and bracketing gives them the insurance they need to make the shot. Seasoned professionals will often vary their exposures, or bracket in order to allow their clients a wider range of choices when making a final image selection. Professional photographers usually bracket in very small increments, such as 1/3 stop, while amateur photographers generally bracket in 1/2-stop increments or more.

Bracketing for effect is often difficult to see when evaluating the results from negative film, either color or black and white. The print, which is the second generation and made

from a negative, can usually be corrected to look proper even when the negative was improperly exposed. The film's latitude for exposure makes possible this correction of bracketing exposures, even when the film was incorrectly exposed. This is one of the major reasons that amateur photographers rely heavily on negative-based films. The margin of exposure error, resulting in an unusable image, is much greater than when using transparency or slide film.

Transparency, reversal, or slide film has little or no exposure margin. Since it is the final product, there isn't another step in the process in which it can be corrected, manipulated, or adjusted. For this reason, those who shoot with this type of

Polaroid makes numerous products for professional photographers. The available range of emulsions makes it easy for photographers to match the Polaroid film in speed and type to the final film. It's great instant proofing film.

film will bracket their exposures more often than those shooting negative films. Some feel that a very small amount of underexposure makes colors brighter when using reversal film. For this reason, it's important to test the different types of films before using them. Know each film's benefits and limitations.

Of all the important discoveries and advances in modern photography, perhaps one of the most interesting and, possibly, important is the invention of Polaroid films. When Dr. Edwin Land developed his revolutionary photographic products, he may not have fully realized the impact they would have on the professional photographer. His primary market was the consumer. By taking a picture and instantly seeing the results, the public at large became excited about photography and began using Polaroid cameras and film at an amazing rate.

This "instant" technology has also played an important role in the daily lives of professional photographers for many years. Most of the modern professional cameras have adaptable film holders or magazines that will accept a variety of different types of Polaroid film, color as well as black and white. By using this film during a photo shoot, the photographer can see the composition, check the subject's expression, watch for camera or flash malfunctions, and much more.

This image was shot with Polaroid Pro100 679, showing the quality of this type of film.

The quality of Polaroid films has continually improved over the years to the point that the instant picture, taken with a professional camera, will result in a very acceptable photographic image. Some black-and-white Polaroid films even offer a processed negative at the same time the instant print is produced. The negative can be peeled away from the positive and saved, washed in a solution, and used to make prints or, under a high magnification loupe, checked for absolute scene sharpness before shooting final images on traditional negative or reversal film. This is a technique often used by commercial advertising photographers.

Photographers can also use Polaroids for evaluating exposures before making the final exposure of a scene on their selected film. This is another avenue of insurance for the photographer who wants to be in complete control of his or her images. By having an understanding of the true or accurate ISO rating (film speed) for the film that you are planning to use for your final photograph, you can match up the Polaroids in terms of film speed and you can match the exposure to the film you're shooting. The accuracy of professional Polaroid films in terms of their effective ISOs can be relied on with confidence.

Using a Flash Meter

EARLIER WE DISCUSSED the differences between reflective and incident light meter readings and how the use of the different light meters will render proper and predictable exposures in virtually every photographic situation, in the studio or outdoors.

When working outdoors, meter readings are taken by *gathering the light* when a button is depressed on the meter. The meter basically reads the amount of light it *sees* on its sensor. However, a meter reading taken using flash or strobe reflects the quantity of light, or flash, in that fraction of a second that the flash or strobe is illuminated. It reads a burst of light and displays to the photographer a suggested aperture based on the film's preset ISO and the output of light from the actual flash. The aperture is the primary exposure control used for the basic exposure of the subject when using flash or strobe lighting.

The studio photographer has many choices of settings. The options include setting in the film's ISO, adjusting the meter to read *flash* or *ambient,* indicating if you are using a sync cord or working in a noncord situation, and in the case of flash readings, the option to set a preferred shutter speed. How you set the shutter speed may have an influence over the flash reading that is establishing the working aperture. For example, if you

were in the studio working with very bright modeling lamps in the strobes, a fast shutter speed setting on the flash meter would assure you that there would be no influence or *contamination* of exposure from the bright modeling lamps, provided you set the camera's shutter speed the same as the meter. The actual exposure would be based entirely on the output of the strobes.

However, by setting the shutter speed slower on the meter, there is the risk of having the brightness of the modeling lamps affect or influence the exposure based on the flash. Consider working outdoors using flash and you can imagine the impact that the shutter speed has on the overall look of the image. When using a fast shutter speed outdoors with flash, you can make it almost appear as if you took the picture at night. Or simply by slowing down the shutter speed, you can produce a completely different look based on the theory that the shutter speed, along with the aperture, controls the ambiance; the aperture alone controls the exposure on the primary subject. A slow shutter speed would lighten up the ambient or available light. The knowledgeable photographer has the entire range within which to work and in time will learn which shutter speed is appropriate for the desired effect.

Here is an example of a comfortable balance between shutter speed and aperture when working with a flash outdoors.

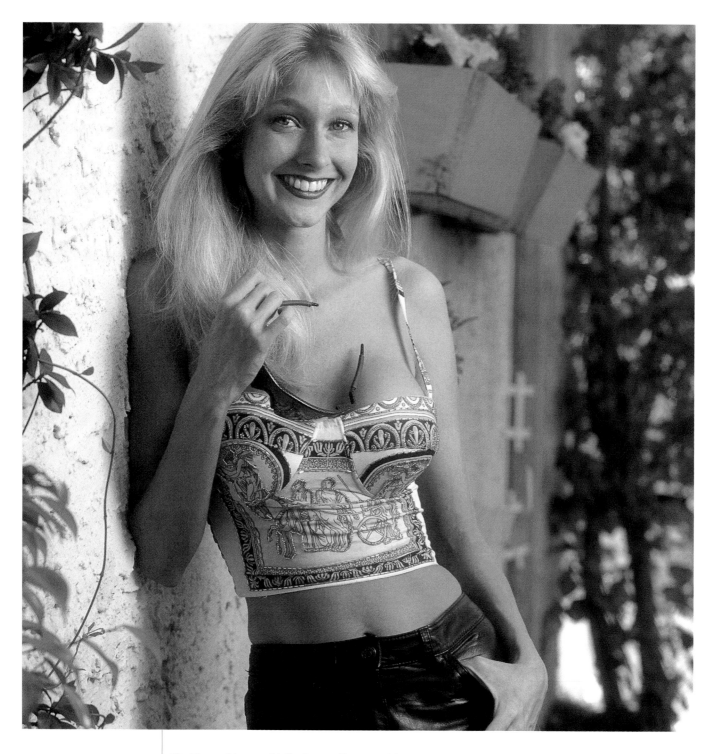

Working outdoors with flash can offer complete control over the brightness of the background. Here, the exposure was 1/60 sec. at *f*/8. Notice the background brightness. A small soft box on a portable flash was used on the subject.

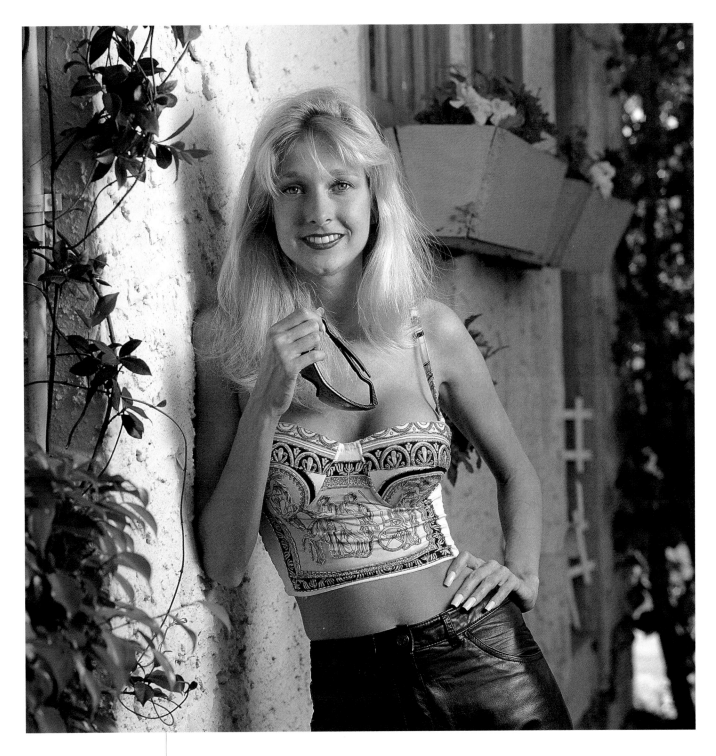

By increasing the shutter speed, the subject stays the
same, but the background becomes darker. When working
with flash outdoors, primary exposure on the aperture
will always be based on the flash, while exposure from
the shutter speed determines the background brightness.

Lighting and Contrast Ratios

WEBSTER'S DICTIONARY defines a ratio as "the relationship in quantity, amount, or size between two or more things." Ratios are important in many different types of photography for a variety of reasons. First, there is the range of contrast you can actually see in a scene—what your eye visually tells you is dark and light. This range of *visual contrast* will vary from person to person, but it is considerable. Think about how well your eyes adjust when you've been in a dark room for a long period of time, as inside a movie theater. As your eyes adjust, you can begin to see more and more detail and more of your surroundings. The same is true when exposed to extremely bright lights, like those from the sun or bright spotlights on a movie set or video lighting.

This visual contrast is what allows you to see the detail of a pencil deep inside a briefcase on an airplane while at the same time finding detail in the brightest areas of the clouds outside the airplane window when you quickly turn your head and look out. The reaction of our eyes is one of the most fascinating yet perplexing aspects of photography. It is fascinating because of the incredible contrast range the eye can see. And, it's perplexing, because you don't often get on film what your eyes told you you were seeing. For many years photographic educators and magazine articles have taught techniques for learning to see light and how it reacts on film. However, photographers must realize that the film's reaction to a scene's contrast is less than what the eye can see, and it must carefully be understood.

All this means that you have to think more. You must think about the importance of testing all of the different films you use, to know what their tolerances are and how to best utilize this information. Manufacturers of sensitized products can list the film speed, but you must individually discover how you use it in terms of contrast and to best suit your own working conditions.

The second area of contrast to investigate is the *film contrast*. After testing the range of contrast of films, you find that the film cannot see the same amount or range of contrast as the human eye. The fact is that *what you see* is not always *what you get*. Different films, each with their own individual characteristics, will have greater or lesser ranges of contrast. What you see as the apparent range of film contrast is also, as mentioned previously, controllable in the processing of film. Overdevelopment increases the appearance of contrast while underdevelopment does the opposite, diminishing or decreasing contrast.

You can choose how much detail you wish to see in the darkest dark or in the brightest bright area of an image. You must learn not only to control the range of contrast, but also to know when to use high contrast or low contrast and use the proper tools and/or techniques to achieve the desired effect.

"Highlight to shadow" *ratios* in portrait photography, especially in the studio, are of particular importance. Let me first say that ratios are as subjective as almost every other area of photographic lighting and no single rule will apply to all situations. However, there are some guidelines that might help new photographers achieve a ratio that represents dimension and depth while yielding full detail in highlights and shadows.

In order to determine what ratio (or contrast) would be correct for a given scene, you must have an understanding of what is possible. Let's start by discussing how the amount of light measured on either side of a face—the highlight side and the shadow side, as in a portrait situation—will vary and how physics plays a part in determining the ratio.

For a traditional portrait, a ratio of 4:1 is one of the more popular, as it's a ratio that defines light direction and renders visible, yet dark detail in the shadows (on the opposite side of the face from where the main light strikes). The term 4:1

A 2:1 ratio means that the shadow is $\frac{1}{2}$ the brightness of the highlight or true tonality of the subject—a 1-stop difference between the two.

A 4:1 ratio means that the shadow is 1/4 the brightness of the highlight or true tonality of the subject—a 2-stop difference between the two and greater contrast between the dark and light areas.

means that there is four times more light on the highlight side of the face than on the shadow side (in photography *four times* equals two *f*-stops). The importance here is that there is not only acceptable contrast from highlights to shadows, but there is also a perceived depth. Depth, as previously discussed, is of key importance in much of today's successful photography. This difference in amounts of light on each side of the face helps to identify or create depth and shape. The term 4:1 also means that there's 1/4 the light in the shadow as in the highlight. This is just a different way of expressing it.

Whether you're using one, two, three, or more lights will determine the finer points of reading and understanding ratios. However, the most important thing to keep in mind is the actual simplicity of the process: What you're looking for is the difference in brightness of the highlight side of a face and the shadow side of a face. How they relate to each other in terms

of brightness will help you determine what is the correct ratio for any given subject.

Looking closer at how the 4:1 ratio is achieved working with flash in the studio, you can first shoot a test in the studio with only one light source, positioned at a 45-degree angle to the subject. Take an incident meter reading with the meter placed next to the subject's face, with the dome or sphere of the meter pointed toward the main light. Let's say the reading is *f* 11. Next, read the shadow side of the face with the dome aimed away from the light source, in such a position that no direct light from the main light is striking that side of the face. Let's say that side reads *f* 5.6. The difference between the two sides of the face is 2 stops. This translates to a 4:1 ratio.

Photography works on the principles and laws of physics that state that the previous number, such as aperture or shutter speed, either doubles or halves the amount of light. If the read-

A 8:1 ratio means that the shadow is 1/8 the brightness of the highlight or true tonality of the subject—a 3-stop difference between the two and even greater contrast.

ing was 1-stop difference, reading f8 in the shadow, as in the case of using a reflector for the shadow, there would be half as much light in the shadow as on the highlight side of the face. You could also say that the highlight side of the face had twice as much light as the shadow, or a 2:1 ratio.

Ratios become more complex when you introduce a fill light in the studio, but they still can be measured and read using the same basic idea. For example, if you place a fill light behind the camera position and get a reading of f8 with a main light at a 45-degree position to the subject and it has a reading of f11, think about the ratio like this: If the subject, a face in this example, is looking forward, the f8 from the fill light falls equally on each side of the face. To make this easier to understand, we'll use a simple standard and say there is one unit of light on each side of the face. When you add the light from the main light from one side, you are adding light to one side of

the face, not necessarily the other. In this case, f11 adds two units of light to the highlight side of the face because f11 is effectively two units of f8. Therefore, we have one unit of light on the shadow side of the face from the fill light, and a total of three units of light on the highlight side from the main light, combining the one from the fill light and the two from the main light. The result is a 3:1 ratio.

You can apply this to any subject or object you photograph. Just learn to think in terms of units of light for factoring the ratios. If the main light reads f11.5, the total ratio would be 4:1. Having f16 on the main light would mean a 5:1 ratio. As mentioned above, ratios are only important for reasons having to do with possible contrast ranges of films and papers. In other words, if a photographic paper or magazine page will only hold 4 stops of contrast, it's your responsibility as a photographer to keep the photograph within that range.

KEEPING It SIMPLE:

In most of my lectures and workshops, I try

to teach techniques dealing with light theory

and make an effort not to place too much

emphasis on actual setups. I want to stress

individualism in photography, and while we

do learn from one another, and I recognize

this is an important aspect to teaching, we

have to learn both from and for ourselves in

order to truly gain confidence in our work. It

is, however, important to illustrate a few key

items, and in this chapter, I'll use a one-light

scenario to do this. Many photographers

have been highly successful working in this

simple way. One light often creates drama

and shows clearly a "single light direction."

One-Light Setups

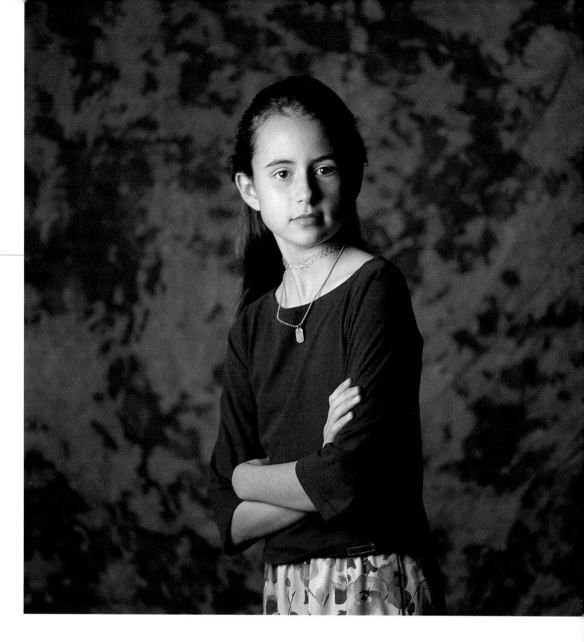

A portrait taken with one light in a studio can resemble a window-light portrait.

Placing the Light

OF PRIMARY IMPORTANCE when working with a single light source is the exact placement of that source. Depending on the angle of coverage of the lens in use, as well as the angle of throw or degree of illumination of the light source, there can be as much as 300 degrees of area in which the light can be placed and still not be seen by the camera. In fact, the light can also be placed directly behind the subject (whether a person or an object), again depending on the desired effect.

Another one-light photograph. This simplistic approach allows the photographer much more interaction with the client.

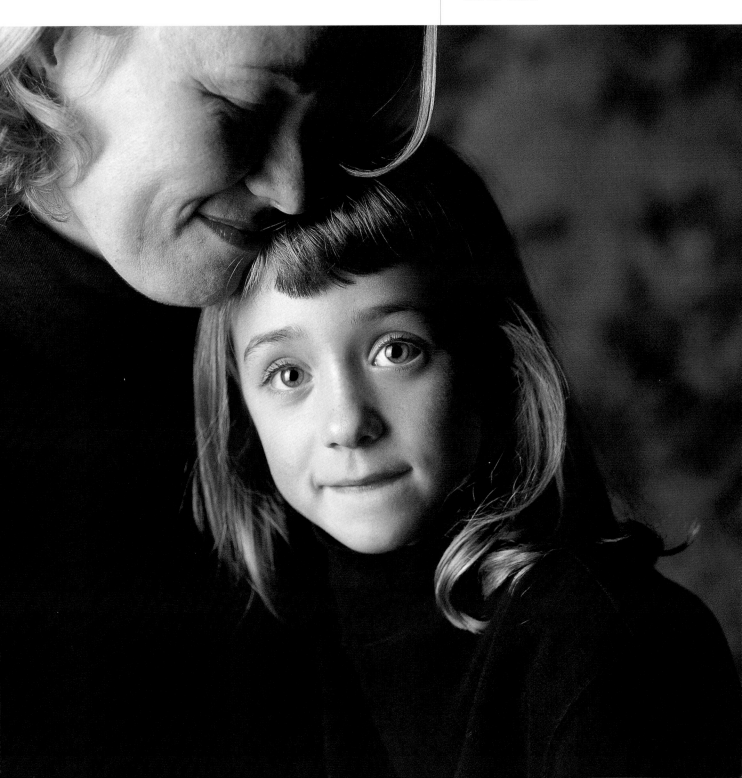

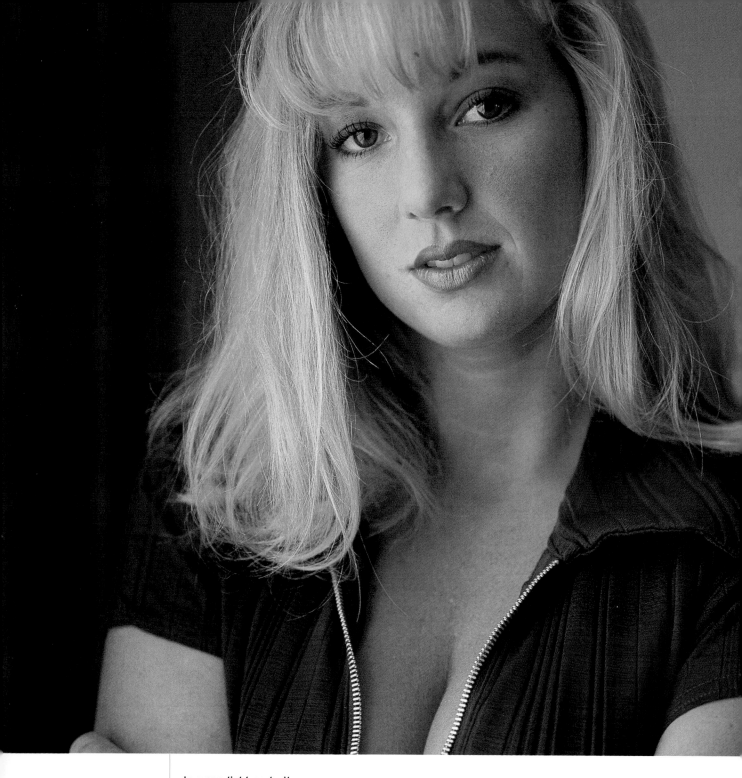

In a one-light portrait, you can turn the light in such a way as to illuminate the background, increasing your efficiency. By working with one light, you're forced to get creative and clever.

Light placed near the camera's position gives a flat, nondirectional look to the photograph. No true shape or dimension is shown.

As the light source begins to travel around the subject, notice how the shadows and highlights change not only the mood of the picture but also the shape and "look" of the globe.

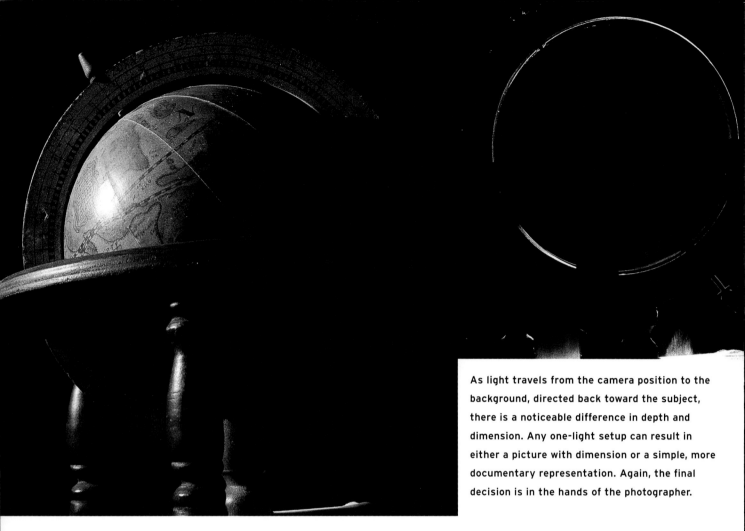

As light travels from the camera position to the background, directed back toward the subject, there is a noticeable difference in depth and dimension. Any one-light setup can result in either a picture with dimension or a simple, more documentary representation. Again, the final decision is in the hands of the photographer.

Try setting up the following test to see the different effects of a single light source on a subject from a variety of positions. Utilizing a simple, three-dimensional object and working with an assistant, take a look through the camera while your assistant moves a single light source slowly in a big circle around the object. Make sure that the object is far enough away from a background, wall, and so on, so that there are no distracting shadows behind the subject.

In this test you want to concentrate only on the main subject matter. With the light close to the camera's position you'll notice, when viewing through the camera, that the object has little or no depth or dimension. There are few, if any, highlights and no real shadows to see from this position; shadows from the object fall well behind it. The object will also reveal no texture, smooth or rough, or any sense of what the surface material might be. As you move the light further away from the camera,

the subject starts to take shape. As the light starts to create direction, the subject starts to reveal itself and how it might best be photographed. Again, you can only see this looking through the camera. You should never place lights without looking through the camera. It's impossible to foresee the final result of a lighting effect without looking through the camera. However, keep in mind that there are no hard and fast rules on light placement. If it looks good to you, shoot it.

A few interesting things occur as the light travels, at an angle, away from the camera. First, there is the obvious directional feel just mentioned.

Second, there is a feeling of drama as the light becomes extreme to the camera's position (or, as the light moves away from the camera, more toward the background). This drama generally will enhance a photograph as long as the directional light is not a detriment to your particular subject.

When photographing any surface, including a face, texture often brings out true character. In this example, a directional light enhances the portrait.

Texture

TEXTURE IS CREATED by directional light, plain and simple. It is one of the key results of directional lighting (light traveling at an angle to the camera). The direction will create highlights and shadows, creating peaks and valleys on the surface of your subjects, and if these peaks and valleys are not present, texture cannot be seen.

There are times that this texture is exactly the effect you're after. But there are certain subjects that directional light may not enhance or complement. A good example might be an elderly person with a lot of character lines in their face. These lines will be made more pronounced with directional light.

Depending on the photo, this can be either a good or a bad thing. At the same time, when shooting a commercial or advertised product, such as a refrigerator or a wicker basket, texture will show the viewer exactly what the product looks like and whether the surface is porous, pebble grain, smooth, highly polished, leather looking, and so on. Again, this effect may be desired or not. The main point is that while directional light can help many photographs, it can hurt just as many. Take the time to study the subjects you photograph and try to capture them in the most pleasing light possible. If texture helps, great. If not, use a more flat lighting.

Textured products are enhanced when the direction of the light is established to create highlights and shadows on the surface.

Again, texture adds
character to this
lovely portrait
of my grandmother,
"Miss Lou."

Lighting here captures the subtle texture in the background and the more obvious texture of the subject's sequined dress. Remember that the sequins appear as highlights, reflecting the large soft box used as the main light.

As discussed in previous chapters, the size of a light source dictates the sharpness of the shadow edge and the size and intensity of the specular highlights. This point is even more important when you are using only one light source. Working with a reflector or fill light with a single source allows the photographer the chance to again make all of the decisions regarding direction and size of the source relative to the distance to subject, as well as relative to the size of the subject. The fill light serves only one purpose: to control the amount of contrast on the primary subject. It's the only job of a fill light.

A reflector used opposite the main light reduces contrast and lessens drama. This is often a more desired look in a traditional photograph.

Removing the reflector
results in an image with
much more contrast.

A single light source illustrates the shape of this guitar's edge, again showing how light can reveal true form.

I remember speakers at conventions and workshops, when I was first starting out, saying that fill lights were necessary in portrait photography because all portraits must have a base density, which is determined by the brightness of the fill relative to the main light. They also said that the ratio between the two should be standardized—that shadows always had to have a certain density. The fact is that this statement is only true if *you* want constant density in the shadows—if the ratio is what *you* want. Again, we have the right to choose how we want a person or product to appear in a photograph. Be very careful about doing what others tell you. I will agree that there are times when a fill light is necessary, but let's make it an option or tool, not a rule to always follow. Obviously, there are situations in working with product photography when a base fill exposure is important, especially in working with subjects such as food shots, large constructed sets, and some smaller products.

After many years of working in a portrait studio with a fixed fill light in the ceiling, I gave it up in favor of a smaller and more easily controlled reflector when working with one, two, or three people in a portrait session. This gave me more confidence in my work almost instantly. By using a reflector in a portrait situation, *what you see is what you get*. The ratio or balance between the shadow side of the face with the reflector and the main light side of the face without the reflector is exactly what I see and, therefore, can easily control.

Many unique opportunities exist for one-light photography. Try a few one-light setups of your own and be creative. In some, use a reflector as fill, in others just use the light alone. Remember that there are no rules, only objective physics and subjective opinions.

One-light portraits can offer strong impact and are generally simple to set up. Here, I allowed light to spill onto the background past the subject.

To create and imply depth in a photograph, the photographer uses different types of accent lighting (lights other than the main light or fill light). By the effective use of this lighting, you can separate a subject from the background, show the actual shape of something or someone, and help control the viewer's perception of contrast. It also helps with enhancing texture across any given surface. Overall, photographers who are utilizing accent lighting successfully, whenever appropriate, are probably full-time working professionals who recognize the benefits; many advanced amateur photographers may

Lighting for Depth

have the eye and technical skills for creating high-quality work but might be missing some of the small nuances that separate them from the full-time pros.

Working without an accent light makes it difficult to determine the true shape of the face and allows little separation from subject to background.

The addition of an accent light not only reveals the true shape of the subject, it also helps add sparkle or "snap" to the picture.

The Options

Several years ago, there was a trend in traditional studio portrait photography of working with five lights:

1. Main or key light

2. Fill light

3. Hair light

4. Separation or edge light

5. Background light

We've already discussed main and fill light a bit, so to better understand how to create depth in a photograph, let's explore the uses and means of controlling the latter three of these lights.

HAIR LIGHT

There are those who think because a portrait has a hair light (a light illuminating the sitter's hair) it must be good. However, a poorly controlled hair light, or one for which the photographer didn't pay attention to direction or brightness and quality, might be a detriment to a photograph.

There are as many theories on hair lights as there are on every other aspect of photography, so follow your own feelings. I know people who have a fixed hair light in the ceiling of their studios over their shooting area, and I know those who would never consider this. Who is right? They both are. They are fulfilling something they, or their clients, want or need, not the opinion of another photographer. It would be

The simple addition of a hair light can often make the difference between an average photograph and something more exciting. Compare this image with the hair light to the top one on page 124 without it.

unfair to judge how any photographer works. We don't know their parameters.

I once heard a well-known photographer say a hair light should be increased in power to be brighter for dark-haired subjects and turned down to be less bright on blonde or light-haired subjects. I've thought about this statement a lot over the past few years and have come to the conclusion that I disagree. My first reaction would be to agree and just move on. But if you think about it, light is all about creating and controlling contrast in a scene. When photographing a subject with dark hair, think about the amount of light it would take for a light coming from a strong angle behind the subject, back toward the camera's position, aimed at dark hair.

The fact is that you can power your hair light down considerably and still have a successful hair light on dark-haired subjects because it will be seen easier and sooner than if the hair were lighter in tonality or color. In fact, my standard rule of thumb is to have the hair light 2 stops *below* my working aperture if the subject has dark hair. For example, if I'm shooting at $f16$, I want the hair light to read $f8$. As the hair gets lighter, I power up the hair light until it reads the same exposure that I'm shooting at when lighting blonde hair. Give this some serious thought and testing.

Another important factor in controlling the hair light is its placement. Where should it go? Is it directly overhead, slightly behind, or slightly in front the subject? I have always felt that a

A traditional five-light
setup for portraiture
might include a main
light, fill light, accent
light, hair light, and
a background light.

BACKGROUND LIGHT

HAIR LIGHT

ACCENT LIGHT

FILL LIGHT

MAIN LIGHT

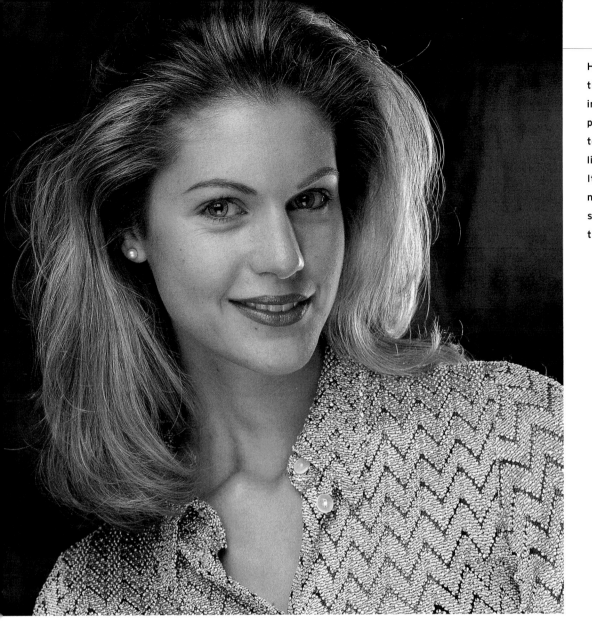

Hair light can be on the top or on the side in more of an accent position. The key to a successful hair light is very simple: It should add detail, not overpower, and show the subject's true shape.

hair light should be exactly that: a light for the hair—not the nose, not the ears, but a *hair* light. To this end we have to look through the camera as the hair light is positioned in order to determine the exact best placement. I know how difficult this is when working by oneself, but it's important to at least establish some of these types of guidelines. Some may choose to mount the hair light permanently in the ceiling and keep the subjects posing area in the same place. This is fine as long as it gives the desired results.

Now, what about the size of the hair light? Does it matter? Isn't a small snoot ideal because it can be aimed? Again, the answers lie within each individual photographer. If you keep in mind the Law of the Inverse Square, you know that as the light

source increases in size, its highlight will diminish in brightness. Imagine that you have a small and very bright hair light on a brunette subject. If you want to lower the brightness of the hair light you have two choices: You can lower the power of the light source, diminishing the brightness without changing the size of the hair light, or you can increase the size of the hair light, which will also diminish the actual brightness.

I often work with a soft box as my hair light for a couple of reasons. First, I am very pleased with the light quality in the hair when working with a large, even light source such as a soft box. Second, there's a unique or different look to your work, and as I said earlier, it's great to be different and separate your work from that of your competitors.

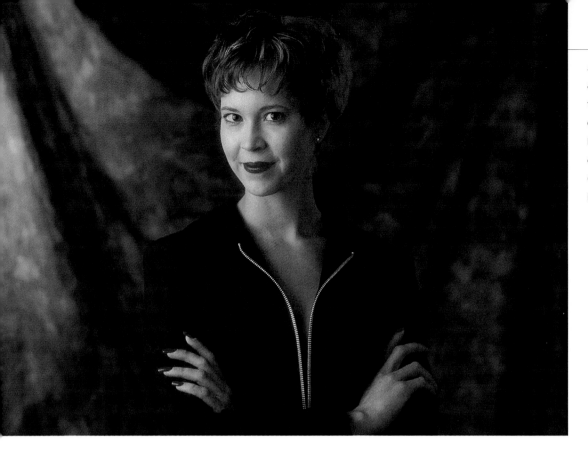

Adding a color to an accent light shows the vibrancy of the color, due to the colored light being added to an otherwise dark area. Once again, depth is the desired result.

SEPARATION OR ACCENT LIGHT

Some commercial photographers refer to this as a skip light, skim light, rim light, "kicker" light, and many other names. Whatever you choose to call it is fine with me. Terminology doesn't make much difference. What is important is to recognize the value of this extra sparkle of light and what it can bring to your photos, whether it be portrait, editorial, or commercial.

Placement of the separation light is of key importance, along with its brightness. In determining placement and brightness, a little common sense can go a long way. For example, the darker the subject and the background, the less brightness you need for separation. This results in the need for less power than some might think, depending on your chosen aperture. The reason is because the brightness or the contrast created by the brightness will be registered by the viewer much quicker than if the subject and background were of a brighter tonality. For example, a dark blue or even black suit wouldn't require great amounts of power or brightness to create separation from the background or to "paint" a rim or edge light around the fabric.

The contrast would be seen easier than if the suit were white. Remember, contrast and separation are the primary goals when attempting to build additional depth in a picture.

In the case of photographing a bride, the separation light would need to be considerably brighter before you could easily see its effectiveness, due to the lack of contrast between the light color of the gown and the white color of light. When photographing a subject that's light in tonality, I will often choose to add color to my accent or separation lights in order to make them "read" easier. Remember that while we all like to think of ourselves as photographers, we are actually contrast controllers often doing nothing more than recording the contrasts that we create in the studio.

These examples apply to commercial photography as well as portrait work. The color and brightness of a given product will often determine how much or little accent lighting is needed for the shot to be successful. Food photographers will often use light skimming across the tops of different types of food to accent or highlight their tips.

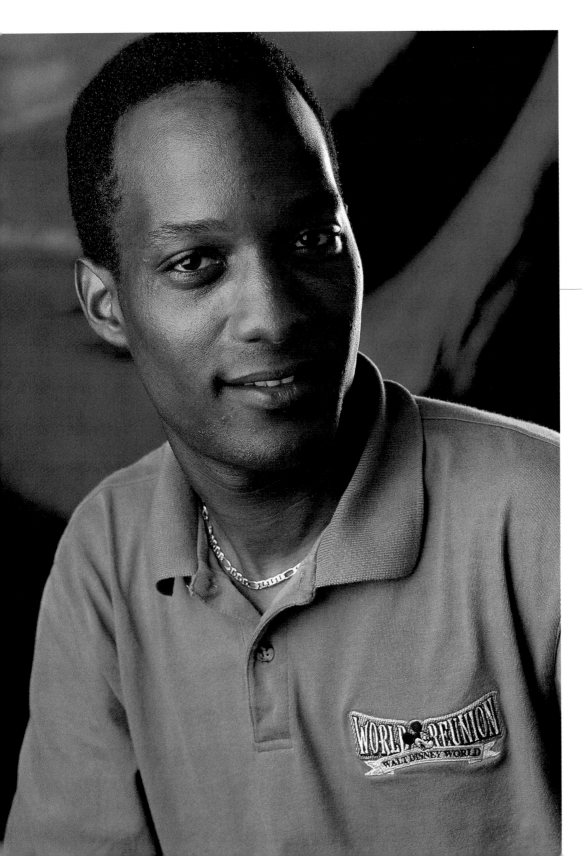

Without the accent light, the subject's skin would simply blend in with the background. The true shape of the cheek and jawline can be easily seen due to the strip light used as accent from the camera's right.

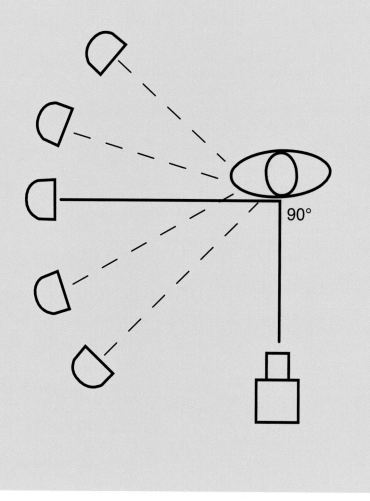

OPTICAL ILLUSION

One of the strangest things that occurs in photography happens while working with hair lights or separation lights. In fact, depending on the exact position, it could also happen to a main light. As a light source moves more than 90 degrees away from the camera's position relative to the subject, the brightness of the light source increases. This is assuming that the distance from the light to the subject doesn't change and the power setting or light output remains constant.

What is strange about this is that, if metered, the light reading would be unchanged as long as the distance from the light source to the subject remains unchanged. In other words, if you draw out an arc or a circle at a set distance from the sub-ject on which the light source could travel, the light source would follow that arc and yield a perfect exposure based on a light-meter reading, as long as the light does not go beyond the 90-degree mark. After that, the light simply becomes brighter and brighter, and the meter can't tell you how much brighter.

This is due to a phenomenon that is based on a physics theory. Much like inertia or the amount of energy necessary for a given task, the energy necessary for light to skim off a subject will diminish as the angle to the subject increases. This then becomes one of the few times I will ever say that you cannot measure exposure accurately with an incident or reflec-tive meter. The meters will be fooled. You have to go on expe-rience in this case and personal taste.

BACKGROUND LIGHT

There was a time when almost all the photographers I know who were involved in people photography would light their backgrounds virtually the same: They would adjust the height of the background light to be between the shoulders of their subject, place the light behind the subject, and aim it directly at a background without any type of light-control device other than the standard 7- to 10-inch parabolic reflector head that comes standard with most lights. Times have changed. Photographers have found out that they can have as much control and exhibit as much creativity in their backgrounds as they can with the rest of the photograph.

In around 1984 I stumbled onto an idea by accident that up to that point I had not seen before. That was the day I took off the standard reflector from my background light and aimed it through a light box. I then moved the newly created large background light to the far side of my background, skipping light across the background instead of firing straight into it. Not only did I revolutionize my work by changing the size of my background light, but also its direction. I started moving this light off-center regularly, out from behind the subject and more along the side of my backgrounds, allowing the skimming light to create texture on the background.

This made for some unusual looking effects. Of primary benefit was the texture I could create, which enhanced the natural peaks and valleys of the fabrics used. Keep in mind that the effects will change dramatically depending on the working aperture of the camera. Softening or sharpening of the background based on the depth of field will certainly affect the final results.

The bottom line is, if you can control highlights and shadows on your subjects by controlling the size of your light source, you can do the exact same thing on your backgrounds. To create and control the look of shadows from draped muslin or the new Custom Superlight backgrounds, change the shape, size, and distance of your background light. Use color theatrical gels for adding impact and excitement. Utilize the light-shaping tools you have on hand and make some new ones if you have to. The main point is to be creative, resourceful, and above all else, different. Separate yourself from your competition by offering things they cannot or do not.

Lighting flat into the background without direction is fine in many situations, such as this product shot. Note that I photographed this Hasselblad accessory display case using the Chromazones system explained on pages 134-140.

By moving the background light to one side and "skimming" it across the background, you can create additional shadows that tend to increase dimension in a photograph.

Once again, a subtle background light can give an added appearance of depth. Selection of lens aperture determines sharpness or softness of the background.

Without the back-ground light on, the background should appear as black before color is added.

Chromazones: Color Background Controls

Several years ago I was fortunate to work with educator/photographer Dean Collins at a time when he was developing a new system for controlling colors on backgrounds called Chromazones. This system was very well thought out and methodical, due to Dean's color blindness, which necessitated the development of the system. Its importance in my own photography cannot be measured. Not only is it important, it's actually very simple to use if you follow a few guidelines, although at first glance it might seem difficult.

GETTING STARTED

Chromazones is a metering system or technique that requires no additional accessories. It is based on the same process as looking for a particular color of paint at a paint store, where customers look at a chart and select the desired color depending on what they like or need. The clerk then mixes the color based on a formula, usually coded in the paint number. For example, you may ask the clerk for a particular shade of blue. The name of the color is usually followed by a code number

that tells the clerk exactly how to mix a combination of colors, usually starting with white, to achieve the desired effect.

The Chromazones color background system works exactly the same way. After creating some lighting/metering tests and color swatches, you end up with a background color and a number (for metering purposes) that you can recall or reproduce on demand, without further testing, on almost any background with any lights and at any aperture, providing a few rules are followed.

The first and most frustrating problem people seem to have with color background control is called contamination. If you've ever tried using colored gels you may have experienced it. Contamination occurs when your results of adding colored gels to a background look flat, washed out, and not quite as bright or colorful as you thought possible. The problem was not the brightness of the light used with the gels but the probable contamination of all of the other lights. Allowing even the smallest amount of light from the other lights on your set to strike the background, effectively does the same thing as turn-

ing up the room lights, even slightly, while trying to view or show slides. The background gets contaminated and the color and contrast disappear.

There's a simple technique that you can apply to avoid this problem. First, as in any photograph, establish your working aperture by taking an *incident light reading* of the subject. Let's use an aperture of $f11$ for this example. Make sure all lights on your set are on with the exception of the background light. Before adding the background light, make sure that the other lights, combined, will not affect the background before you light it with the colored gels.

After establishing your incident light reading and working aperture of $f11$, go to the background and take a *reflective light reading* of the background area that will be in the picture. Again, this reading is taken with the *background light off and all other lights on*. This reflective reading will give a hypothetical 18%, or mid-tone. In order to be sure there is no contamination light on the background, this reflective reading must be at least 3 stops below the incident reading. In this example, with

$f11$ as the incident reading, the meter must read $f4.0$ or below.

If you think about it objectively, any reflective reading will give you 18%. The meter doesn't know if you're using a white background, black background, or even a gray background, and it doesn't care. All it knows is that everything it measures will result in a mid-tone if you do what the meter tells you to do. In this case, it's only being used as an instrument to check relative brightness of the background against the subject.

Three stops below a mid-tone is black, even on a white background. If the reflective reading is 3 stops below the incident reading, the background will appear as black no matter what the tonality, or even the color, of the background.

Now that any background can be made to read as black, once you turn on the background light, the creativity can begin. Your desires or your client's needs will determine how bright or dark you want any given background color. Then simply read the color reflectively again, this time with the background light on, and the final resulting color can be determined, based on an objective test you set up first.

CREATING A SWATCHBOOK OF COLOR TESTS

Once you've reached this point, you have determined that you can indeed do this and that by making the background appear black before adding color, you control how bright and colorful the background can become. The next step is to determine predictability and repeatability, allowing the photographer the same benefit the paint store clerk has available: to accurately predict colors (and the correct metering for them) without testing each one every time.

To set up the test, use a plain gray background and one studio strobe with the standard reflector supplied with the light head, covered with any color gel. For this example, let's use a Roscoe #81 Primary Blue. Turn off all room lights and only turn on the strobe with the gel. This light should be placed approximately 8 to 10 feet from the background or wall and right next to your camera. I work with a Hasselblad camera

and, in this test, usually a medium telephoto lens, possibly 150mm CFi. Set the lens in the middle of the aperture ring, for example at ƒ11. This will make the test go much faster for you, as you'll see later.

Turn on the power to the strobe and begin taking reflective readings on the background, adjusting the power until it reads ƒ11. Once it reads ƒ11, we know that shooting at ƒ11 would give an 18% (or mid-tone) background. However, just because we use a reflective meter does not mean we will always do what the meter says. Be sure you have consulted your meter owner's manual and have a full understanding of how to take reflective flash readings.

The next step is to catalog our efforts. Keep a note pad handy to log in each exposure and description of the gel. As mentioned above, we'll do this test with a deep blue gel from one of the country's leading gel manufacturers, Roscoe. Our

This is a good example of what is considered a zero (0) green. This rating indicates that the reflective reading from the background with the background light on and the gel in place reads the same as the subject reads with an incident meter aimed at the main light source. They are balanced, or there is zero difference between the two.

This actual film strip shows -1, 0, and +1
color. These predictable results are
extremely useful in commercial photogra-
phy for which color becomes more critical
than it is for portrait work.

first exposure with the light set to read *f*11 and the lens set to *f*11 will give beautiful rich and deep blue. We'll call that a zero (0) blue. This 0 blue will approximate the actual color and hue of the gel itself. So the statement can be made that if you want to represent a gel as it truly appears, simply expose it at the same aperture that the meter says reflectively. We're calling it 0 because, as you'll see when there is a subject in the shot, there's no difference in brightness value between the incident value of the subject and the reflective value of the background.

Now, by opening the aperture 1 *f*-stop to *f*8, we'll get a blue that's slightly brighter than a 0 blue. This new, slightly brighter color is called plus 1 blue. Closing the aperture 1 stop from the original *f*11 to *f*16 will yield a blue slightly darker than the first, or a minus 1 blue.

Follow this direction for the test, keeping accurate notes on frame number, gel number, and aperture until you have exposed all of the gels you wish to have in your swatchbook of color, and give each color objective names that tell you the formula for reproducing them. For example, the first one we did, 0 blue, becomes R81 0 (meaning Roscoe gel #81 exposed at the same aperture for a reflective reading). The next frame would be R81 +1, and so on.

It works well to determine your 0 value by adjusting your strobe to the middle aperture of your lens when doing your

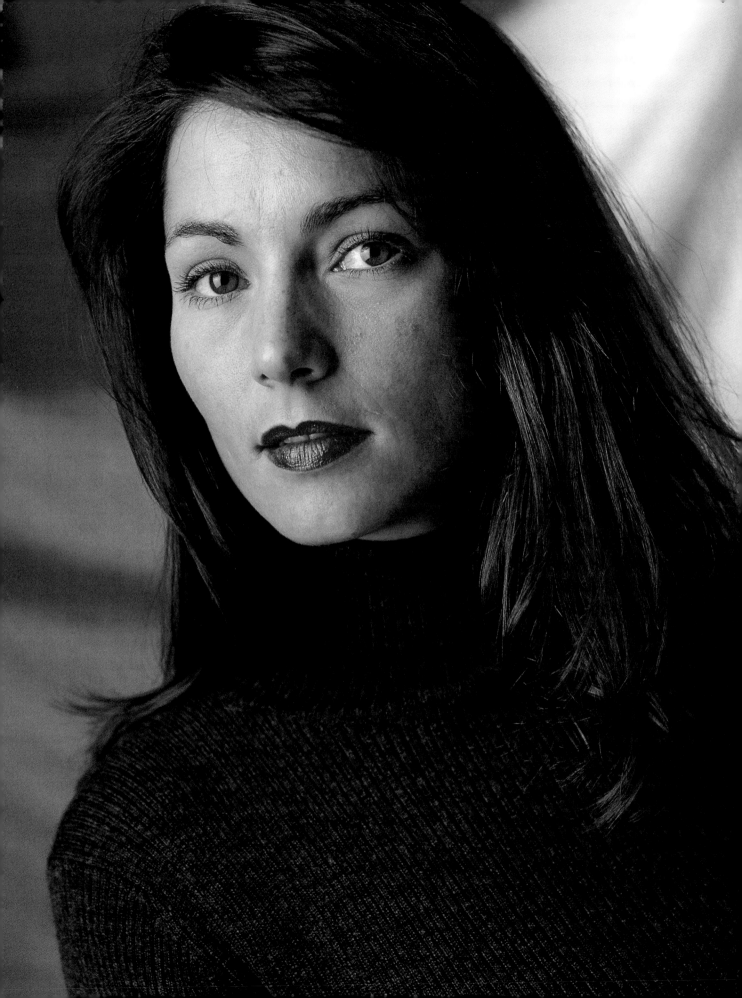

tests, say *f*11, so that once you have it adjusted, you simply change your aperture, opening up and closing down for your color variations in your tests without having to walk to the background for any readings. This way you can very quickly move through a series of colors on film.

Make sure when you set up this test that you are far enough away from the background that your strobe has a large area of coverage, sufficient to cover the image area seen by the lens. This will help give your color swatches a clean, professional look.

A danger to be aware of is that if you do this test with color negative film, the lab has no idea what these subtle changes in color are meant to look like and may subjectively print them at any value they choose. There's no standard by which they should print. For this reason, most people doing this kind of work use transparency film for their color swatch-es. You can use any type of film for the final shooting with a subject in the scene, because everything about applying the test to a real photograph is relative to whatever brightness your subject reads with an incident reading.

However, for those who choose to use color negative film and make prints for their swatches, please follow these guidelines. In frame number one of your color swatch tests on each roll you expose, place a person holding a color chart and an 18% gray card. Then begin your tests without the person starting with frame two. Do this on every roll you shoot. Then, tell your lab to set up their printing data for frame number one's color balance and density, and *do not change it for the rest of the roll*. If your lab will print to the standard you set up in frame number one, they can effectively give the same results and predictability of transparency film, by removing any subjective opinions during the printing stage.

The use of this color Zone system helps save time and testing by providing an understanding of what the final results will be. In these two examples, I was able to easily predict and control the direction—as well as the brightness—of the background bursts.

APPLICATION

After you test your colors and set up your swatches in a notebook or binder, a client can look through the colors and pick anything they want that you have cataloged and labeled; for example R26 +2/3. You know instinctively that they have selected an amber gel that will read reflectively 2/3 stop brighter than whatever you're shooting at on your subject. The actual working aperture doesn't matter. What matters is relative brightness values. For this reason, you can literally work at any aperture with any color on almost any background and produce almost any color and, what is most important, you can do it on demand, first shot, without further testing and without wasting your client's time on the set.

This is a difficult system first time through, but after you've done it once, you'll always have this as one of your greatest tricks of the trade.

Experimenting with color contrast can be creative and exciting. This blue burst is a O blue in the middle and drops off to a -1 and -2 as it falls off on the corners.

Resources

PHOTO EQUIPMENT

Photographers often ask about certain equipment and services that I use. While I hope photographers will find their own labs with which to work, their own camera or photo-supply specialty stores, I have constructed a list of companies and individuals I work with who have made life a little easier.

Cameras

As mentioned in the technical notes on page 5, I use Hasselblad cameras exclusively. Over 400 retailers in the United States offer sales and technical expertise on this great product line. For a complete list of dealers, contact Hasselblad's Consumer Relations Department at (973) 227-7320 or visit www.hasselbladusa.com. Talk with Mark Brady or Bob Raimey.

Lights

VISATEC lights are my brand of choice. They're consistent in color and flash output, and have the cleanest, most accurate light output I've ever worked with. They're also the most durable and reliable, used by the most demanding studios and theme parks across the world. Also available through Hasselblad's networks of dealers, VISATEC lights are featured on www.hasselbladusa.com and www.visatec.com.

Backgrounds

Almost every picture in this book features a background by a company in New York called Custom Superlight Backgrounds by Dianne. These incredible tools are extremely lightweight, in fact the lightest in the world, and can be used almost anyplace with only a couple of clips or hooks. A heavy cross bar and light stand or C stand is not required. For a complete catalog, call (516) 746-0818; contact: Dianne Fleming.

Color Labs

For all of my E-6 processing, I use a lab in San Diego, California, called CHROME. The company has a couple of locations and is regarded highly by professionals who live and work in the area, as well as by out-of-town photographers who finds themselves working in San Diego on projects. CHROME can be reached at (858) 452-1500.

Portable Electronic Flash

Obviously, I work with Hasselblad and use the D-Flash 40 for on-camera flash with dedicated TTL flash metering. For off-camera, I use the Quantum Q Flash. It's superbly constructed and offers a wide variety of features. For more information, call Quantum Instruments at (516) 222-0611; contact: Lorry Rosen.

PHOTO EDUCATION

Over the past 20 years, I've found that there are a number of locations at which photographers can receive the best possible education in terms of workshops and one-week and two-week schools. These are entities that offer superb value in terms of educational dollars and make available numerous choices in content.

Palm Beach Photographic Workshops

Located in beautiful South Florida, PBPW is one of the more aggressive in terms of content and workshop instructors.

Phone: (516) 276-9797

Santa Fe Photographic Workshops

The southwestern US location of the Santa Fe Workshops is one of the most beautiful in the country and is creatively perfect for attending photographic workshops.

Phone: (505) 983-1400

Maine Photographic Workshops

One of the longest running, most established of all the workshops, this one is also in Maine, an ideal location to study photography and film as well as digital imaging.

Phone: (207) 236-8581

Tuscany Photographic Workshops

The rolling hills of beautiful Tuscany in Italy are the setting for this extraordinary workshop experience. Many of the world's top photographers teach TPW each year. For more information contact: info@TPW.IT or visit their website at www.tpw.it

International Wedding Institute

The only location in the world concentrating on wedding photography, IWI was a brainchild of mine in 1998 and has grown to one of the most talked-about locations at which to learn the techniques of wedding professionals. It's held in Tucson, Arizona, in August each year and presented by Hasselblad University. Contact Hasselblad USA at (973) 227-7320 and ask for information on IWI

Dean Collins

A quick look at Dean's website offers a variety of informative, educational topics. From lighting to digital to PhotoShop techniques, Dean has established himself as one of the world's premier educators.

www.deancollins.com

In addition to these workshops there are 24 separate week-long schools that, affiliated with the Professional Photographers of America, offer great values for the education dollar. For a complete listing, contact PPA at (404) 522-8600, and ask for Erin Metcalf. An especially valuable school in their stable is the Texas School of Professional Photography. Contact them at (806) 296-2276.

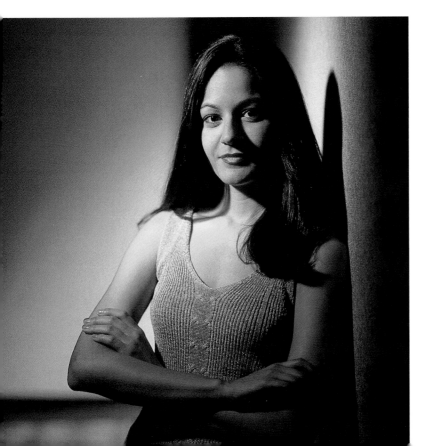

Index

A

absorber, 65
accent light, 28, 31, 34, 35, 38–39, 122–141
ambient, 67, 98
angles, of incidence and reflectance, 70–71
aperture
 and background, 133
 and flash, 98–99, 101

B

background light, 24, 25, 28, 30, 34, 40–41, 62, 63, 100, 101, 110, 112, 117, 121, 124, 126, 129, 130, 131–133
 color, 134–141
backgrounds, resource for, 142
bare bulb, 50, 62
barn doors, 56, 57, 62
basic strategies, of studio photography, 14–41
Blair, Don, 38
blue, zero (0), 137, 141
bowl reflectors, 62
bracketing, 94–96
burning in, 66, 67

C

cameras, 142
catchlights, 56, 74, 80, 81
Chromazones, 131, 134–141
Collins, Dean, 12, 59, 134, 143
color, and accent light, 128
color background controls, 134–141
color labs, 142
color tests, swatchbook of, 136–139
comp book, 27
contamination, 98, 134–135
continuous light, 66–67
contrast, 31, 34, 36, 37, 59, 65, 72, 82, 118, 119
contrast ratios, 102–105
control, light, 68–83
cookie, 62

D

Deglau, Terry, 53
depth, 22, 23, 24, 25, 30, 31, 34, 38, 41, 111, 112, 122–141
diffusion panels, 48, 58–59, 60
dimension. See depth
direction, 22, 23
 single-light, 108–121
distance. See placement
documentary approach, 16–17, 20, 21, 112
dots, 65

E

edge, shadow, 76–79, 82–83, 118, 120
edge light, 124
education, photo, 143
electronic flash, 44–47, 66–67, 142
equipment, 42–67, 142
exposure, 84–105
 film and, 92–97

F

feathering, 57
field of light, 50–51, 52–65
fill light, 28, 31, 34, 35, 36–37, 118, 120, 126
film, and exposure, 92–97
film contrast, 102
filters, 82
fingers, 65
flash, setting, 98
flash, electronic, 44–47, 66–67, 142
flash meters, 86, 98–101
focusing spots, 50
foreground light, 25, 28, 40, 41
freezing, 67
frontlighting, 22, 23

G

gathering the light, 98
gobos, 15, 48, 49, 59, 65
gray cards, 87, 88
green, zero (0), 136
grids, soft box, 56
grid spots, 48, 49, 50, 51, 62, 64
grip, lighting, 65

H

hair light, 38, 124–127, 130
highlights, 20, 21, 35, 56, 71, 77, 80–83, 111, 115
 specular, 72, 74–75, 76, 80, 82, 117, 118
highlight to shadow ratios, 102–105, 120
honeycombs, 49, 56
hot lights, 66–67

I

incidence, angle of, 70–71
incident meters, 86, 88, 89, 90–91, 130, 135
insert fronts, 64
interpretative approach, 16, 17–20, 21

K

key light, 28, 32–34, 36, 124
kicker light, 38, 128

L

labs, color, 142
lab standards, 90
Land, Edwin, 96
large-field light modifiers, 52–65
The Law of the Inverse Square, 75, 127
light. See also specific sources
 continuous, 66–67
 measuring quantity of, 84–105
 placement of single, 108–114
 types of, 28–41
light control, 68–83
lighting
 and contrast ratios, 102–105
 for depth. See depth
lighting effects, recognition of, 27
lighting equipment, 42–67, 142
lighting grip, 65
light meters. See meters

light modifiers, 15, 22, 38, 48–51
large-field, 52–65
light quality, 72–73
light size, 34, 56, 71, 72–73, 74–75, 76–79, 80, 82, 118
light-subtraction panel, 62
louvers, 56

M

main light, 22, 28, 29, 32–34, 36, 41, 118, 120, 124, 126, 130
measuring quantity of light, 84–105
meters, 86–97
 flash, 86, 98–101
 incident, 86, 88, 89, 90–91, 130, 135
 reflective, 87–89, 130, 135
 testing of, 92
mono light, 47
motion, 66, 67

N

notebook, 27

O

one-light setups, 41, 106–121
optical illusion, 130
optical spots, 50, 64
outdoors, 26, 41, 98–101

P

parabolic reflectors, 51, 57, 62
photo education, 143
photo equipment, general, 142
photography, studio, basic strategies of, 14–41
physical characteristics, of subject, 23
placement, 34, 56, 71, 74, 75, 76
 in one-light setup, 108–114
plan, deciding on, 26–27
Polaroid films, 96–97
portfolio, 27
position. See placement
purple, 138, 139
push process/pull process, 94

Q

quality, light, 72–73
quantity, light, 84–105

R

ratios, contrast, 102–105
reflectance, angle of, 70–71
reflections. See highlights
reflective meters, 86, 87–89, 130, 135
reflectors, 15, 31, 36, 37, 51, 57, 58, 59–60, 61, 62, 65, 118, 119, 120
resources, 142–143
rim light, 38, 128

S

Schatz, Howard, 27
scrims, 48, 65
seminars, 27
separation light, 31, 38, 124, 128–129, 130
setting, 25
shadow edge control, 76–79, 82–83, 118, 120

shadows, ratio of highlights to, 102–105, 120
shallow collar reflectors, 62
shoot-through umbrellas, 54
shutter speed, and flash, 98–99, 101
single light direction, 108–121
size, light, 34, 56, 71, 72–73, 74–75, 76–79, 80, 82, 118
skim light, 38, 41, 128, 130, 132
skip light, 128, 131
snap, 54, 124
snoots, 48, 62, 64, 127
Snowden, Lord, 41
soft boxes, 32, 33, 35, 48, 50, 51, 55–56, 58, 62, 72, 81, 82, 83, 100, 117, 127
soft-light circular reflectors, 57
specular highlights, 74–75, 76, 80, 82, 117, 118
speed ring, 55, 56
spill light, 28
spotlights. See spots
spot meters, 89
spots, 33
 focusing, 50
 grid, 48, 49, 51, 62, 64
 optical, 50, 64
 stacking, 54
strip lights, 48, 51, 56, 129
strobes, studio, 45, 46–47, 62, 66–67
studio flash, 46, 47
studio photography, basic strategies of, 14–41
studio power packs, 46–47
studio strobes, 45, 46–47, 62, 66–67
subject, consideration of, 21–23
swatchbook of color tests, 136–139

T

testing, of meters, 92
tests, color, swatchbook of, 136–139
texture, 23, 71, 78, 79
 in one-light setup, 114–121
thinking, like studio photographer, 16–21
time, as image element, 66
true tonality, 91, 103, 104, 105

U

umbrellas, 33, 48, 50, 51, 52–54, 55, 62, 80, 81

V

visual contrast, 102

W

window light, 41, 72, 73, 108
workshops, 27, 107, 120
WYSIWYG, 31

Z

zero (0) colors, 136, 137, 139, 141